7/05

Altered

Book

Collage

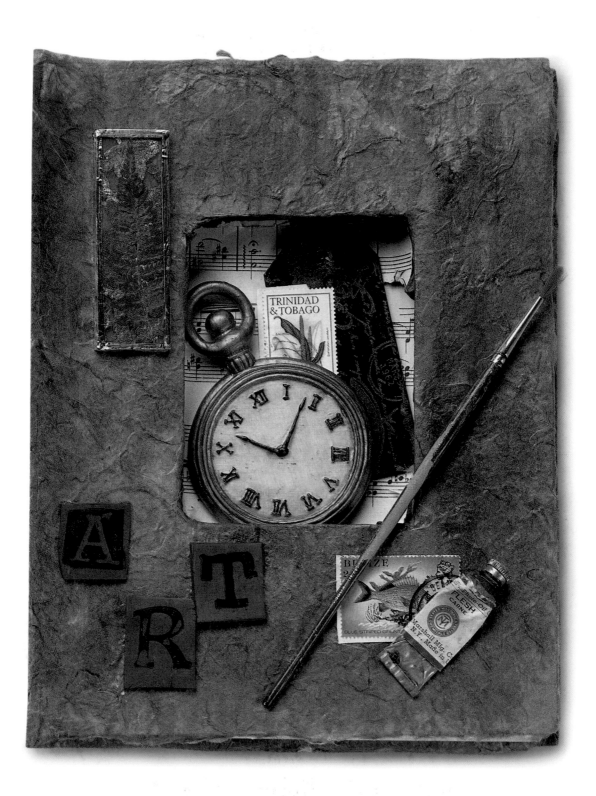

Altered
Book
Collage

Barbara Matthiessen

702-81

Sterling Publishing Co., Inc.
New York

PProlific Impressions Production Staff:
Editor in Chief: Mickey Baskett
Copy Editor: Phyllis Mueller
Graphics: Dianne Miller, Karen Turpin
Styling: Lenos Key
Photography: Jerry Mucklow
Administration: Jim Baskett

Library of Congress Cataloging-in-Publication Data Available
Matthiessen, Barbara.
 Altered book collage / Barbara Matthiessen.
 p. cm.
 Includes index.
 ISBN 1-4027-1410-6
1. Altered books. I. Title.
TT896.3.M29 2005
702'.8'1--dc22

 2004016482

10 9 8 7 6 5 4 3 2 1

Published by Sterling Publishing Co., Inc.
387 Park Avenue South, New York, N.Y. 10016

© 2005 by Prolific Impressions, Inc.

Produced by Prolific Impressions, Inc.
160 South Candler St., Decatur, GA 30030

Distributed in Canada by Sterling Publishing
c/o Canadian Manda Group, 165 Dufferin St.,
Toronto, Ontario, Canada M6K 3H6
Distributed in Great Britain by Chrysalis Books Group PLC,
The Chrysalis Building, Bramley Rd., London W10 6SP, England
Distributed in Australia by Capricorn Link (Australia) Pty. Ltd.
P.O. Box 704, Windsor, NSW 2756 Australia

Manufactured in China

Sterling ISBN 1-4027-1410-6

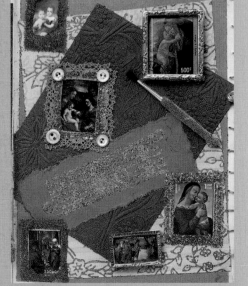

About Barbara Matthiessen

Barbara Matthiessen has a specialized degree from an interior design school and worked for a design firm before entering the craft industry as a full time freelance designer. She has written 43 booklets, contributed to 19 multi-artist books, and created countless designs for magazines.

While continuing to design for publication, Barbara also works for manufacturers, developing kits, project sheets, and sales models. She has been very active in the Society of Craft Designers as a member of the board of directors, working on various committees, acting as chair of the mentoring program for two years, and chairing the 2002 seminar.

ACKNOWLEDGEMENTS

I would like to thank the following manufacturers for their support while I was writing this book and preparing the project samples.

For paints, decoupage medium, stencils, foam stamps, and dimensional adhesive: Plaid Enterprises, Inc., 3225 Westech Dr., Norcross, GA 30092, 678-291-8100, www.plaidonline.com

For rubber stamps: All Night Media, 3225 Westech Dr., Norcross, GA 30092, 678-291-8100, www.plaidonline.com

For inks: Tsukineko, 15411 N.E. 95th St., Redmond, WA 98052, www.tsukineko.com

For vintage papers, trims, and transparencies: Artchix, www.artchixstudio.com

For adhesives and decoupage medium: Duncan Enterprises, 5673 E. Shields Ave., Fresno, CA 93727, 559-291-4444, www.duncancrafts.com

For adhesives: Beacon Chemical Co., 914-699-3400, www.beacon1.com

Table
of
Contents

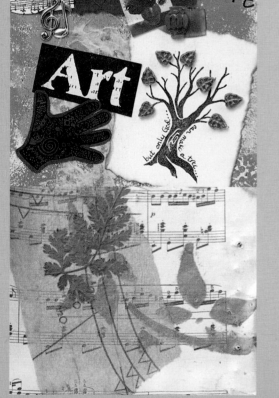

Introduction

ALTERING IS ABOUT NO STRESS, FREEDOM OF EXPRESSION, AND ENJOYING THE EXPERIENCE. PERHAPS SO MANY PEOPLE FIND PURE JOY IN THE FREEDOM OF ALTERING BOOKS BECAUSE THERE ARE NO RULES. . . YOU DO NOT NEED TO BE ABLE TO DRAW, PAINT, OR EVEN CUT A STRAIGHT LINE TO ALTER A BOOK.

From the Author

Book altering can be many things - it's been called a lifestyle, addiction, the ultimate in recycling, and a way to

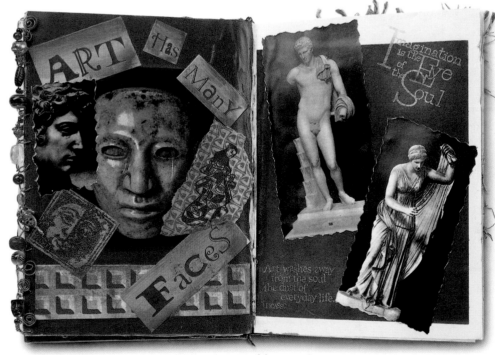

liberate the artist within. I have found it to be all of them. Altering books is a way to express yourself and have some fun. Feeling like an artist will make you an artist. By working on altered books, artists often get in touch with their thoughts, emotions, and ideas.

Altering is about no stress, freedom of expression, and enjoying the experience. Perhaps so many people find pure joy in the freedom of altering books because there are no rules. When you make an altered book, you are the ultimate judge. The book has to please only you and no one, even expert alterers, will critique your art. You do not need to be able to draw, paint, or even cut a straight line to alter a book.

Time and space are not problems either. You can make an altered page spread in minutes or make pages anywhere you have a square foot of space. You can even make a tiny supply kit to carry on trips and bring home an artistic record of your journey. Spending days, weeks, or months on a book is another possibility - it's up to you.

With so many choices, knowing where to begin can be confusing. This book will show you how to start your first book, explain the supplies used, and illustrate a variety of techniques. When you begin, you will see the world in new ways, find potential elements for your book everywhere, and marvel that you overlooked these items in the past. How were you to know odd game pieces, broken watches, or labels could become art?

An outgrowth of the altered books phenomenon is the artist groups that are springing up to provide a network for round robins, swapping materials, and social interaction. I am grateful to my group, Art's Angels, who generously provided projects for this book. Each of the multi-talented artists in the group shared techniques and hints to make your altering experience more fun and rewarding. To find out more about this group go to www.8angels4art.com

Feel free to play and experiment with your book; you might find hidden talents. Hopefully you will enjoy freedom of expression and experience the pure joy of creating. May altering free the artist within you.

The Process

To alter a book is to take an old book and give it new life as a personalized art piece. The process of altering can involve cutting, pasting, painting, stitching, sewing, beading, stenciling, decoupaging - just about anything you want. (That's what makes this such a liberating, joyous art form.) You change, adapt, and customize the book to fit your artistic vision.

A book chosen for altering is most often a book headed for a landfill and not valuable, except as a base to build upon. You are not destroying a book; you are improving it as you turn it into art.

Making an altered book is an art form anyone can do. You do not need to be able to draw, paint, or write poetry to make an altered book. You do not need to spend a great deal of money on tools or materials. All you need is a desire to express your creativity, some time to exercise your creativity, and a few household supplies.

History

Books have been altered for centuries, starting as a way to recycle valuable paper or parchment and vellum derived from animal skins. During the 11th century, monks scraped ink off old vellum manuscripts to add their own text and illustrations. The term for this altering is "Palimpsest"; its earliest known example is the Archimedes Palimpsest, a mathematical treatise on reworked parchment. (You can view it on-line at www.thewalters.org/archimedes/frame.html.)

Other examples of book altering are Victorian illustration and "Grangerism," a form of scrapbooking that uses books as the base. In Victorian times engravings and drawings torn from some books were pasted into other books to illustrate them. Starting in the late 19th century and continuing into the early 20th century, people pasted contemporary ephemera - recipes, family photos, and newspaper and magazine clippings - into old books.

Modern Palimpsest, book altering, is said to have been inspired by artist Tom Phillips, whose altered book *A Humument* is considered by many to be THE altered book. Phillips purchased a novel for pennies and reworked every page. A master at text masking, he highlighted a few words on a page and created a painting to reflect those words. (You can view his masterpiece at www.tomphillips.co.uk/humument.)

Altered Book Groups

Participating in a group is educational and a way to make friends who have similar interests around the world. Thanks to the Internet and the popularity of altered books there are many on-line groups you can join. On-line group members are artists from around the world who leave messages on lists, share photographs, and organize round robins and swaps.

Round robins are groups of people who work on each other's books. There are different guidelines for each round robin that direct where and when to send books to the next artist.

Swaps are exchanges of supplies such as papers, photographs, or embellishments sent to a person who mails other supplies to the participants.

What Is Collage?

A COLLAGE IS A WORK OF ART THAT IS CREATED WITH A COMBINATION OF RELATIVELY FLAT HANDMADE OR FOUND MATERIALS BY ADHERING THESE MATERIALS TO A BASE OR WITHIN A FRAME. COLLAGE IS A VARIABLE METHOD OF ART; THERE ARE AS MANY STYLES AS THERE ARE COLLAGE ARTISTS. SOME WORKS HAVE A MESSAGE OR A THEME; OTHERS ARE SIMPLY AN ARRANGEMENT OF ELEMENTS INTENDED TO PLEASE THE EYE. THE RANGE OF EXPRESSION THAT CAN BE COMMUNICATED THROUGH COLLAGE IS VERY BROAD.

There are perhaps as many definitions for collage as there are artists making them. A common link is that they attach various elements to a base in a pleasing arrangement. The base in this case is a book page. The elements can be nearly anything you can glue or mechanically attach to the page.

The act of assembling components to make an image that pleases the maker - the artist - is the foundation of collage. Collage artists know there is no "right" place for that piece of paper; the perfect arrangement is one they like.

Collage Basics

A simple collage consists of a background and foreground elements. The text or photographs on a page can be your background, or you can prepare a background using tissue papers, inks, paints, rubber stamps, printed papers or fabrics. Design elements such as stickers, trimmed paper or fabric motifs, or photocopies are placed on top of the background. Most artists improvise placement, using trial and error and keeping in mind a few basic design concepts:

- Repetition - Repeating the shape, color, or texture of a compositional element. Sizes or tones of a color can be varied as long as the elements appear related.
- Focal Point - The focal point is a place the eye is drawn to naturally. It is tempting to place this important element in the center of a collage - but try placing it slightly off-center, either to the side or up and down for more interest. Remember surrounding

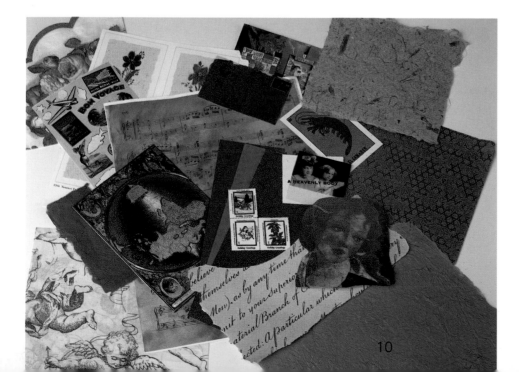

elements also affect your focal point and can drawn interest away from it.

- Balance - Size, color, and texture all determine the weight of an element. A quarter-sized piece of dark paper will appear "heavier" than a piece of ivory lace twice its size when placed on a light background. Strive for a balanced feeling among the elements in your collage.
- Symmetry and Asymmetry- To create symmetry in a design, imagine a line down the center (either horizontally or vertically), with identical elements on both sides of the line. Asymmetry occurs when balance is not based on a central line or axis and identical elements. An asymmetrical arrangement might have one large element off center towards one corner with two smaller elements

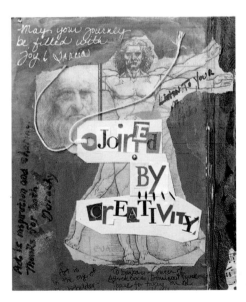

diagonally across from it.

- Texture - Vary the texture of design elements. A smooth background topped with rough, torn, handmade paper is one example. When working with textures, consider the amount of reflected light - smooth objects often appear shinier than bumpy ones.

What to Do with Your Altered Book

Complex Collages

Adding layers makes a collage more complex. Stacking layer upon layer can produce a unique piece of art. There are no hard and fast rules regarding how much of each layer should be visible; however, unless you plan a very symmetrical piece, allow each layer to show a different amount. (Example: Inked and stamped background - 30%, torn tissue paper - 40%, photocopies - 20%, clay embellishments - 10%.)

Another technique that increases complexity is to use portions of other collages as elements. Photocopies of other collages, enlarged or reduced, can be used as backgrounds or layered elements.

Displaying Books

For many, the best part of creating an altered book is sharing their vision and talent with others. To that end, the book should be visible and easily accessible. Holding, interacting, and relishing each page of an altered book is an enjoyable experience.

Your altered book can also function as a decorative element in a room. Place books - propped open - on tables or shelves where they can be seen. A series of books lining a shelf makes an artistic statement, while a single book on an easel has an air of importance. Hang books as wall art, using plate racks, or attach picture frame hangers to the covers and hang them that way.

Showcase your book as you would any fine collection, taking into consideration the book's size and shape. If your book contains fragile or rare items you might choose to place it in a display case or cabinet.

Altered Books as Gifts

Many altered books commemorate major life events such as weddings, anniversaries, and births. Altered books made for these purposes take on major importance because the amount of thought, care, and work that goes into developing an altered book makes it a rare gift indeed.

For children, you could alter a book to reflect the year of their birth or their family history. For a child's book, choose a board book and use child-safe materials and techniques. Add lots of texture, movement, and sparkle. Or alter a classic holiday book, adding family photographs, fun secret compartments, texture, and moveable objects.

Building a Page

WHILE THE PHILOSOPHY OF ALTERED BOOKS IS "ANYTHING GOES," SOME CONCEPTS WILL MAKE DESIGNING YOUR PAGES EASIER AND MORE STYLISH - CHOOSING A THEME OR CONCEPT, DECIDING ON MECHANICS AND SUPPLIES, AND A FEW DESIGN PRINCIPLES.

Choosing a Theme or Concept

Basing your book on a theme or concept helps in making design decisions and links your pages into a cohesive work of art. Choose a theme that is meaningful to you and that you are excited about spending time developing. Themes can be emotions, such as love or fear or curiosity, or a favorite pastime, such as gardening, reading, sewing, or golf. You might also choose a concept like nature or a time in history or even your family tree. Don't be concerned if someone else has used the theme or concept; your book, done your way, is your personal statement.

When you have chosen a theme, start collecting design elements related to your theme. Once you start collecting you will find elements in many unexpected places from yard sales to junk mail. Gathering supplies will help you develop an eye for the potential in ordinary things and also start page ideas brewing in your head. Collecting is a large part of the creative process. Enjoy it!

Place supplies together that you feel you would like to incorporate on one page. This will give you an idea for a starting point. Feel free to make changes at any point along the way.

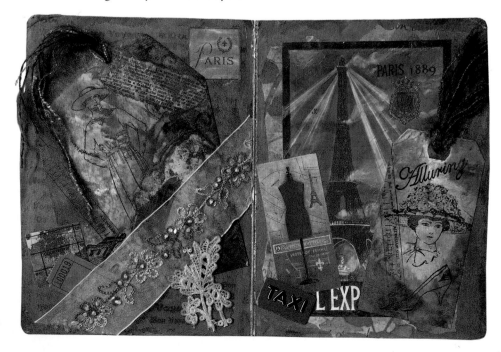

Considering the Mechanics

The term "mechanics" refers to how your book is built. Will there be windows, niches, doors, foldouts, or

pop-ups? The elements you've chosen for pages affect the mechanics; for example, niches are necessary for three-dimensional elements; you may need to allow for their bulk in other ways such as placing them on the cover or removing pages. Windows, doors, and foldouts can highlight a special flat element or give more prominence to ordinary pieces. For movement, consider adding foldouts, pop-ups, small books within your book, flags, or tags.

Some mechanics affect not only the page they are built on but adjacent pages as well. Windows show the adjacent page and are a design element on the page they are cut into. Doors often lead to other pages; flags and tags often show over page edges. When designing, it is important to consider the effect on adjacent pages.

Design

You probably know more about design than you think you do. Landscaping a yard, putting together a clothing ensemble, and decorating your home all involve the use of design principles. Most likely there are color combinations that you are drawn to and textures you find interesting. Use what you already know and like when designing your book pages.

Looking at other artists' work is another way to learn about designing. By studying the project photographs, you will see how to use backgrounds effectively, how subsequent layers are added, and how the elements tie together to make a work of art.

Design elements to keep in mind when envisioning pages or covers include; choosing a focal point (the main element that attracts your eye), creating flow (to keep the eye moving around the page), and unity or repetition (to join the page elements).

Backgrounds

The background is the first layer on your page and should be an integral part of the design. Text, diagrams, drawings, or photos from your book can be effective backgrounds. Papers, inks, paints, mica powders, and a variety of other mediums can be used to create backgrounds. When choosing your background, consider the other elements you will be adding to the page so they will work together.

Layers

After you have chosen a background, arrange additional elements on the page in layers, adding three-dimensional pieces last. How to arrange page elements is primarily an intuitive process - whatever looks good is right. When you have a pleasing arrangement, take a digital photograph of it or place a piece of sturdy cardboard on top that's larger than your pages. Holding the stack firmly, flip over the whole works. Your elements will be in the correct order for attaching to your page.

Mistakes!

Do not allow fear of making a mistake hamper your creativity. Oftentimes a mistake will turn out to be the most interesting part of a book or lead you to spectacular technique. Remember the saying, "Mistakes are just opportunities for growth."

However, if you really dislike a page, there are ways to fix it:

- Remove the page from the book, using a craft knife and cutting mat.
- Cover the page with opaque paper, a layer of paint, fabric, or gesso and start over.
- Punch or cut holes in the page, removing unsightly areas.
- Cover part of the page with another layer.
- Add hand lettering or computer printing.
- Label the page "Experiment" or "Do not try this at home."
- Cut slits in the page and weave ribbon or fabric or paper strips through the slits.
- Cover most of the page with pockets, envelopes, or tags.

General Supplies

THIS SECTION DISCUSSES THE GENERAL SUPPLIES YOU CAN USE FOR CREATING YOUR BOOK.

Choosing a Book

Old books are the starting point for your altered book collage project. Choose a book with a sturdy spine or use a board book. (Board books are thick-paged children's books.) Rummage sales, flea markets, library sales, and thrift shops are good sources for inexpensive books.

If possible, choose a book with a subject matter that reflects the theme of your collage. For instance, select a gardening book if you have a nature theme, a cookbook for a food or recipe theme, or a travel book for a vacation theme.

Practical Considerations When Choosing a Book:

• Choose a hardbound book with at least 200 pages.

• Check the paper in the book to make sure it is in good condition and will not dissolve or crumble. Pulp-type books or those with tissue-thin pages will be difficult to work with, and most techniques will not be possible.

• See if there is interesting text, drawings, or photographs you can incorporate.

• Think about how you want to finish the cover. If the cover is in good shape and has an interesting texture, only light embellishment may needed. A slick-finish book cover (common on many textbooks) may need to be primed and completely covered.

• The slick-surface pages of board books will need to be primed.

Adhesives and Attachers

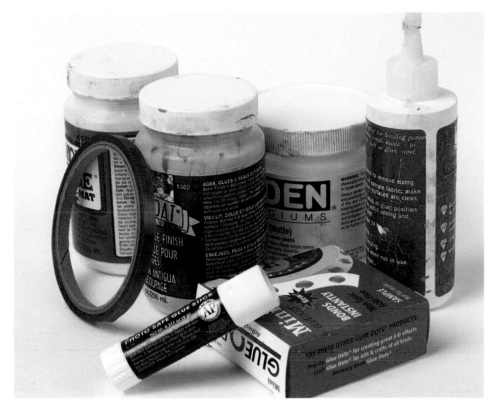

The types of adhesives and attachers to use for your collage depend on availability, the surfaces being adhered, and the desired end result. **Glue sticks**, **pastes**, **double-sided tape**, and **adhesive coatings** can be used to glue paper items to your collage. All work well and help to keep your pages flat. To prevent wrinkles on pages (unless you want wrinkles), choose a glue with as little water as possible.

Decoupage medium and **gel mediums** in a matte sheen can be used to glue paper or fabric to book pages. Both also can be used to create special effects. Decoupage medium can be used as a glue and a finish. Gel medium is found where art supplies are sold. It makes a great glue, or can be mixed with acrylic colors to create impostor effects.

Non-waterbased adhesives, such as **all-purpose industrial-strength glues**, **jewelry glues**, **hot glue**, and **silicone glues** are ideal for attaching non-paper items and heavier embellishments. **Dimensional adhesive or dimensional fabric paint** is great for attaching heavy objects such as beads and charms.

You can also use **wires**, **screws**, **brads**, **eyelets**, **clips**, **staples**, **photo corners**, **tacks**, **hook-and-loop tape**, **safety pins**, **sewing thread**, and **embroidery floss**. You'll find numerous examples in the Ideas section.

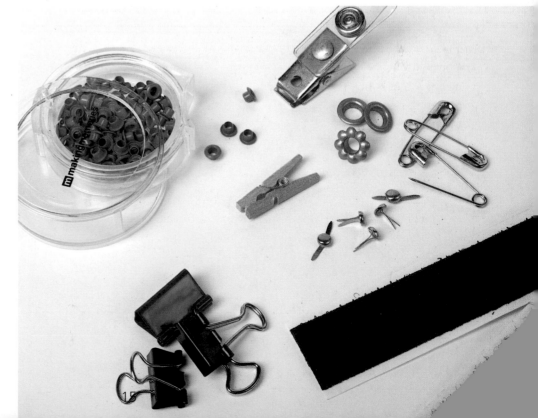

Colorings for Pages

Book pages can be more attractive when they are colored or dyed. These types of coloring agents work well:

Stamping Inks: Inkpads and bottles of ink called re-inkers are used with rubber stamps, to color backgrounds, and to color embellishments. Pigment inks and some dye-based inks need to be heat set or sealed - follow the manufacturer's instructions regarding application and drying time.

Acrylic Paints: Acrylic paints can be used to color backgrounds, for stenciling and stamping, to color embellishments, and to add detail work.

Watercolor Paints: Watercolors make soft drifts of color when used sparingly on a page, allowing text, line art, or photographs to show through. **Aqua crayons** give a similar effect but require less water.

Pens and Markers: Ballpoint pens, gel pens, permanent markers, and watercolor markers can be used to add details and handwritten text and to outline key elements. Be sure to test all markers and pens on a scrap of paper from your book or on similar paper to see if the ink bleeds through.

Chalks and Pastels: Chalks and pastels create a matte finish that's ideal for backgrounds, to color photocopies, or to highlight another design element. Check the packaging to see if the chalks or pastels you are using need to be sealed. Some chalks sold specifically for scrapbooking and rubber stamping do not need sealing.

Colored Pencils: Use colored pencils to add soft, controlled color on pages or photocopies.

Crayons: Use crayons to create vibrant to subtle backgrounds. Metallic crayons add sparkle. Areas colored with crayons need to be sealed.

Household items such as coffee, tea, and bleach can also be used to affect the color of your pages.

Walnut ink or "Nussbaumbieze," is a walnut-colored ink imported from Europe. Its name is derived from its color - the ink is made from peat, a mixture of decomposed plant material and water, that has been dried and ground into granules. The granules, which have been likened in appearance to instant coffee, are dissolved in water to make the ink. Depending on the amount of water used, the color can range from light to dark. It can be used with brushes (bristle, foam, or sponge), in pens, or with rubber stamps to produce a variety of effects on paper. It can be used over acrylic paint, watercolor paints, or colored pencils. Water will remove the dried ink - you can paint, stamp, spray, or spatter the inked surface with water and, when the water is blotted with a paper towel or tissue, some of the ink comes with it. You can buy walnut ink at most stores that specialize in stamping and memory crafts.

Sealers

When choosing a coloring agent, be aware of if and how it needs to be sealed to prevent pages from sticking together. **Acrylic spray-on sealers** are easy to use and do not wet your pages. Choose a finish from matte to high gloss that works with your design. **Acrylic floor wax** can also be used; apply a light coat and buff with a soft rag.

Decorating Supplies

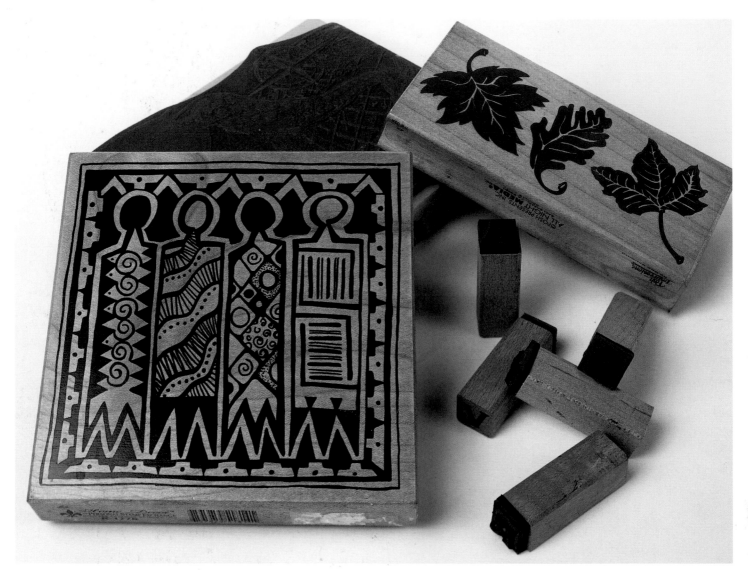

Rubber Stamps

Rubber stamps can be used for backgrounds, as focal points of designs, and to make frames and borders that highlight other elements in your design. They come in a huge array of designs and motifs. You can also have stamps custom made at office supply stores.

Stencils

Pre-cut stencils are available in a huge variety of designs and motifs, including alphabets. Use them to create borders, spot motifs, repeating designs, and lettering. You can also buy stencil blank material and cut your own stencils with a craft knife. Use a stencil brush or a sponge-on-a-stick applicator to apply liquid coloring agents through the stencil openings. You can also use colored pencils for stenciling or use an embossing tool to create stenciled designs.

Foam Stamps

Foam stamps come in many shapes and sizes. Use them to add motifs and create borders.

Transfer Papers & Transfer Mediums

Transfer papers and mediums allow you to transfer photocopies and clippings to your pages. Gel medium, packing tape, and some commercial transfer papers and mediums work only with toner copies. If you wish to transfer a print from an inkjet copy, purchase a transfer paper made specifically for it.

Papers

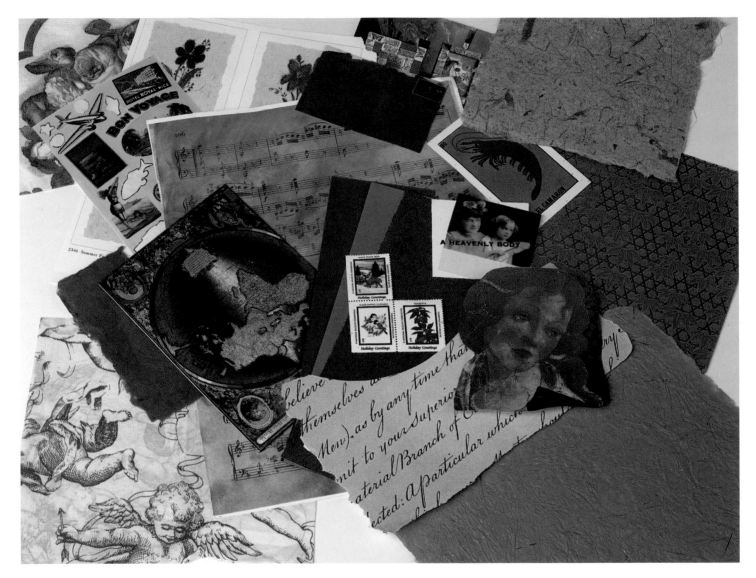

Almost every type of paper imaginable can be used in an altered book. Here are some examples, listed in alphabetical order:

Brown bags

Clip art (copyright-free art from clip art books or the Internet)

Decorative papers

Decoupage paper

Embossed paper

Ephemera - printed matter of passing interest such as newspaper clippings, schedules, etc.

Found Papers (labels, wrappers, tickets, clippings)

Graph paper

Greeting cards

Handmade paper

Letters

Maps

Metallic paper

Napkins

Photocopies of personal photographs

Postcards

Sewing patterns

Sheet music

Stamps

Text from your project book

Tissue paper

Vellum

Woven paper

Wrapping paper

Embellishments

The sky is the limit here, as long as the embellishments you choose are within the scale and scope of your book. If you wish to close your book, use flatter embellishments or cut niches to hold them. In books that will be displayed open (the most common style), you can use items with more dimension.

Here are some ideas and examples of embellishments:

• **Sewing supplies** - Buttons, snaps, zippers, laces, ribbons, fibers, string, fabric, floss, tassels

• **Hardware items** - Washers, nuts, bolts, hangers, metal flashing and sheeting, wires, metal or fiberglass screen

• **Office supplies** - Tags, labels, clips, rulers, staples, stickers

• **Jewelry** - Beads, stones, findings, charms, wires, broken jewelry

• **Games and toys** - Dice, dominos, cards, game pieces, tiles

• **Found objects** - Lids, keys, watch and clock parts, electronic parts, glass bobbles, slide holders, seashells, leaves, sticks, bones

• **Anything not nailed down!**

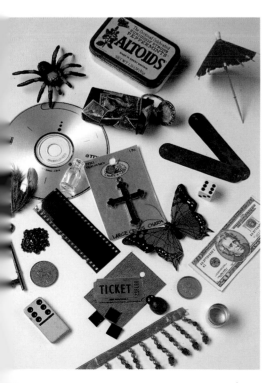

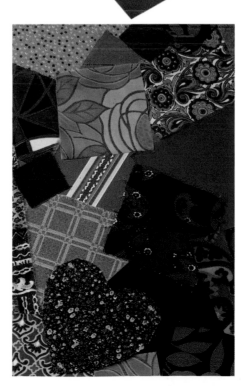

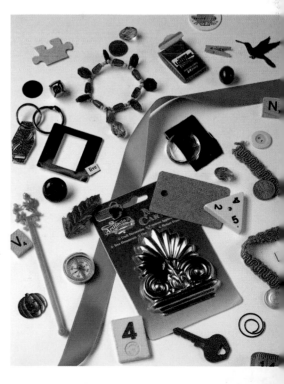

Tools

You'll need a few basic tools to create an altered book. A basic tool kit would include:

Punches, such as hole punches and decorative design punches, for adding interest to pages.

Decorative edge scissors, for creating different edges (scalloped, pinked, deckled, wavy, etc.) on papers.

Punches, decorative edge scissors

Cutting tools, such as **scissors**, a **craft knife**, and a **metal straight edge**, for cutting items for your collage, plus a self-healing **cutting mat**.

Straight edge, craft knife, scissors, utility knife

Brushes and sponges, including bristle brushes, sponge-on-a-stick applicators, sponge brushes, cellulose sponges, and sea sponges, for applying color, mediums, and adhesives to book pages.

Bristle brushes, cellulose sponge

Brayer

Setting tools, for attaching eyelets and snaps.

Brayer, for rolling out air bubbles when gluing items to pages.

Embossing Tool, for embossing papers and vellum.

Embossing tool

General Instructions

THIS SECTION SHOWS VARIOUS BASIC TECHNIQUES FOR CREATING ALTERED BOOKS. YOU'LL SEE HOW TO PREPARE YOUR BOOK, GLUE ITEMS TO PAGES, AND CUT WINDOWS, DOORS, AND NICHES.

Preparing Your Book

Decide What Pages to Keep

Carefully look through your book for pictures, diagrams, line art or text you might want to use. If the pages you want to use are close together it is better to remove some of them. Remove pages by placing a cutting mat between the page to be removed and other pages. Cut the page next to the spine using a craft knife. (photo 1)

Protect the Cover

Protect the book cover while you're working on the inside by wrapping it in plastic wrap. Wrap the front and back separately with a double layer of plastic wrap. Allow the wrap to stick to itself and you won't need tape to hold it in place. (photo 2)

Create Your Working Pages or Blocks

The paper in most books is very thin, so a single page is too fragile for collage. To make a sturdy working surface, you'll need to glue three to fifteen pages together. These groups of pages are referred to as **working pages** or **blocks**. They are the surfaces on which you will create your collage designs. (There are a couple of exceptions to this - if you are using the folding or weaving techniques described later in this book or if you are cutting a niche.)

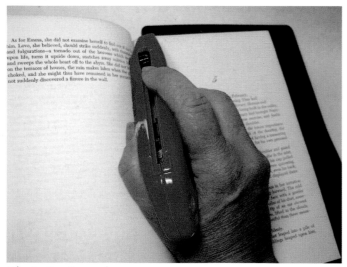

Photo 1 - Removing a page.

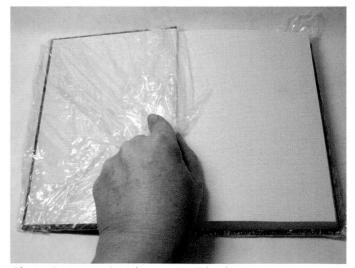

Photo 2 - Wrapping the cover with plastic wrap.

Photo 3 - Spreading glue on a page.

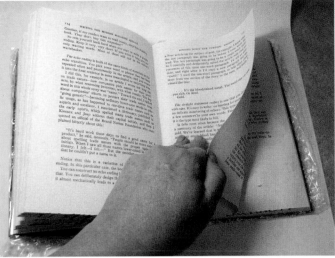
Photo 4 - Cover the glued page with an adjacent page.

Photo 5 - Sanding the slick pages of a board book.

Photo 6 - Coating the surface with gesso.

To make working pages:

1. Spread your choice of glue or paste on a page (photo 3).
2. Cover with an adjacent page (photo 4), smoothing the paper from the center outward. Repeat this step until the glued stack is the thickness you need.
3. Place sheets of wax paper between glued page sections.
4. Place the book in a vise or weight with a heavy object until the glue has dried.

Priming Slick Surfaces

If you are using a board book with slick pages or have a slick-finish book cover you want to cover, you will need to prime them with gesso or cover them with fabric or paper. Gesso can be purchased at art supply stores; it comes in white or black. Here's how:

1. Lightly sand the slick surfaces with 100 grit sandpaper or fine steel wool. (photo 5)
2. Wipe with a damp paper towel or tack cloth.
3. *Either* coat the surfaces with gesso (photo 6) *or* decoupage them with fabric or paper. For a smooth working surface, apply two to three coats of gesso, sanding lightly between coats. Polish the last coat by rubbing it with a piece of a brown paper bag.

Gluing

Properly adhering elements to your pages is important to both the appearance and longevity of your work. Here are some tips for getting and keeping it together:

- Match your adhesive to the surfaces being glued together. The types of surfaces an adhesive is intended for should be plainly stated on the label.
- Apply an even coat of adhesive to the surface, extending the adhesive right up to the edges.
- To achieve a flat surface on papers and fabrics, use a brayer to work out all air bubbles.

Allow glues to properly set and cure. This could mean not proceeding with your project for hours or overnight.

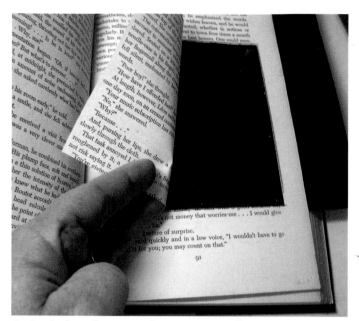

2. A window shape cut from a group of pages.

Cutting Windows

Use a series of windows to make a dramatic statement; a single window can highlight a special part of a design. Place windows so they highlight text or pictures or add a design element.

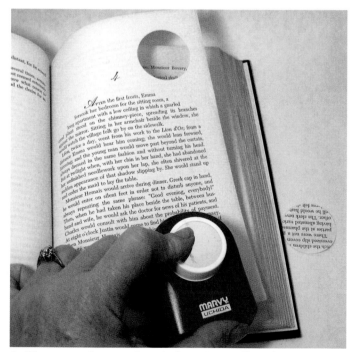

3. Use a punch to make windows in smaller, thinner groups of pages. Reserve your punched pieces for possible later use.

1. Place a cutting mat under the page. Cut the window shape, using a craft knife and metal straight edge.

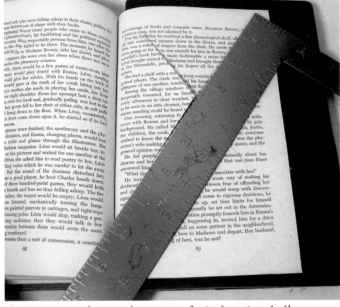

4. You can make another type of window (or shallow niche) by slicing an X with a craft knife. Place the center of the X at the center of the window, cutting out almost to each corner.

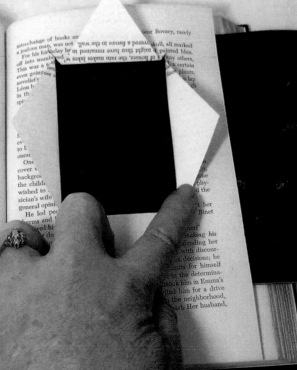

5. Fold the cut triangular pieces toward the sides, making a frame around the window.

Cutting Doors

A door is an opening with three cut sides that can be opened to reveal what's behind it. Doors can be made from the book page or be constructed from other papers or materials. The uncut side is called the hinge.

1. Place a cutting mat under the page where you want the door to be. Using a straight edge and a craft knife for cutting.

2. Cut the door on three sides, leaving the fourth side to work as hinge.

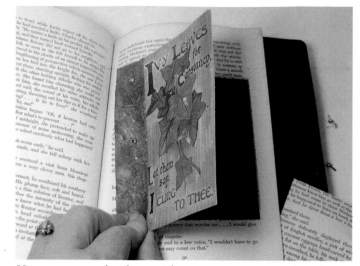

You can cover the door with paper, a tag, a wooden slat, fabric, stamped image, or clay and attach it using brads, tape, glue, eyelets, wires, or hardware hinges or by stitching through the page with a needle and thread. If the door covering is heavy or bulky, you can strengthen the cut door by attaching a reinforcing hinge (a strip of flexible material). In this example, a painted strip is glued to the door cover as a reinforcing hinge before attaching it to the book with brads.

Cutting Niches

Niches are deep windows that can hold three-dimensional objects. What you will place in the niche determines the niche's size, placement, and depth.

Before you cut a niche, make a block of pages using one of two methods. Make the block as thick as the depth of the niche you want to cut.

MAKING A BLOCK

Method 1 - Glue & Clamp:

1. Clamp the pages together for the block. Do not include the book cover or a page or two in front of and behind the block.
2. Brush paste or gel medium across the outside edges of all the pages. Set aside to dry.

See photo at top of next page.

Making a Block – Method 1

Method 2 - Clamp, Drill & Screw:

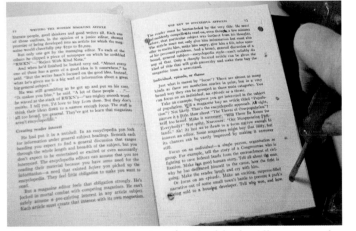

1. Clamp the pages together for the block. Allow a couple pages to remain free in front of and behind the block. Do not include the book cover.
2. Find screws the same length as your desired niche depth. Use an electric or hand drill to make holes slightly smaller than the screws in all corners 1" in from edges and every 1" to 1-1/2" in between. For multiple niches, drill holes in each corner of each niche.
3. Install the screws.

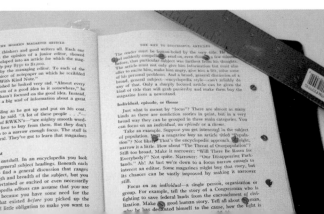

CUTTING THE NICHE

4. Place a cutting mat under the block.
5. Using a straight edge and a very sharp craft knife, cut through all pages in the block.

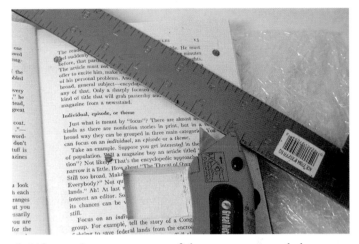

6. Lift out the cutout areas of the pages to reveal the niche. If you used screws to create the block and you don't want them to show, glue a page or two over the screws to cover them after you cut the niche. Cut the niche opening in those pages after the glue dries.
7. Finish the sides of the niche by applying a coat of gesso. Let dry, then paint or decoupage the edges for a more finished look.
8. Decorate the page behind the niche. Glue the page behind the niche block. ❑

101 Ways to Alter a Book

HERE ARE SOME IDEAS TO GET YOU STARTED.
NO DOUBT YOU CAN THINK OF MANY MORE!

1. Use crumpled plastic wrap to apply inks to pages.
2. Stencil paints or inks through household items such as screening, an onion bag, or a doily.
3. Glue in a piece of needlework.
4. Tip in an old report card, greeting card, or postcard (see page 68).
5. Wind thread, yarn, or lace around pages.
6. Rubber stamp with one color of ink over entire page.
7. Rubber stamp with all colors of ink using one stamp.
8. Glue a scene clipped from a magazine. Put a personal photo in the scene.
9. Make parts of a scene three-dimensional by gluing cotton or string (or anything else) on them.
10. Glue on a pants or jean pocket. Fill with tags, papers, flowers, or photos.
11. Weave ribbon, fabric, or paper strips through the pages or around the edges.
12. Use markers, pencils, or pens to draw around or mask text or add to designs to drawings.
13. Glue in foldouts, such as maps or origami pieces.
14. Rearrange the order of the original text. Try making the ending first.
15. Glue on envelopes, filling some and leaving others empty for future treasures.
16. Sew beads around the edges, using thread or wire.
17. Embroider pages.
18. Glue or wire on embossed metal pieces.
19. Sew on buttons with thread, floss, or string.
20. Glue string, floss, yarn, or threads on randomly or to form a pattern.
21. Tip in a page of a child's art.
22. Cut a series of pages 1/4" shorter than next, then color each differently.
23. Scrape paint across the pages, using a credit card or palette knife.
24. Cover a page with duct tape, masking tape, or electrical tape.
25. Attach snaps, hook-and-loop tape, or zippers to pages.
26. Attach sheer fabric over the pages with eyelets, braids, or stitches.

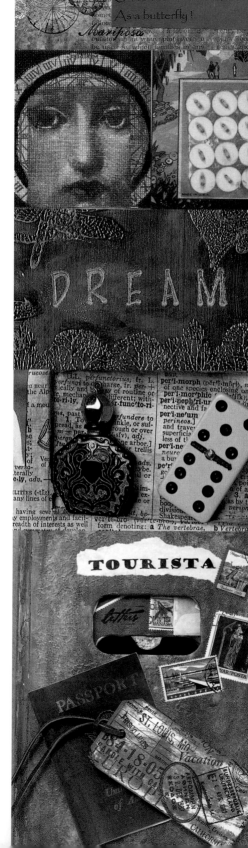

27. Make a mini quilt from paper or fabrics.
28. Cut apart a mylar balloon, then glue to pages.
29. Alter compact discs, then attach. Or use CDs for tabs.
30. Add glitter, sequins, or metal leafing.
31. Glue product labels to pages.
32. Make a collage from candy wrappers.
33. Glue on seeds to make a mosaic.
34. Cut a photograph into square "tiles." Glue on, separating the pieces slightly to make a photo mosaic.
35. Lay objects on a page, then spray paint.
36. Rub decals on pages.
37. Make a clay page or new cover.
38. Cut pages apart vertically or horizontally.
39. Cut pages apart and intermix the pieces.
40. Rub metallic paste over a page or embellishments.
41. Color the squares of graph paper.
42. Glue in pamphlets, brochures, or perfume ads with scented strips.
43. Add a CD with music related to your theme in a case or envelope.
44. Make a ransom-style note from letters clipped from a magazine.
45. Use crackle medium on a page or cover.
46. Spray a page or cover with webbing or faux stone spray paint.
47. Sew dowels, sticks, or stones to your page.
48. Glue on tiny toys.
49. Make up a found poem from book text.
50. Add a mini book.
51. Sand off some images for a weathered look.
52. Use sandpaper for part of a collage or to mask text.
53. Glue a word or small picture under a glass bauble or lens.
54. Glue on postage stamps.
55. Add some game pieces.
56. Paint game pieces all gold or silver or copper, then use them to create a collage.
57. Add plastic critters, such as bugs or lizards.
58. Add paint and glitter to plastic critters, then add to pages.
59. Make polymer clay beads, then sew or glue on.
60. Attach anything flat with photo corners.
61. Attach elements using jump rings, paper clips, staples, bits of tape, or clamps.
62. Use your book as a journal or diary and write in everyday events. Include daily ephemera.
63. Punch holes in a line or design.
64. Glue or paint the page behind a punched page, then glue the pages together.
65. Attach yarns, threads, strings, cords, or fibers to spine or pages.
66. Cover a page with all sorts and sizes of tags.
67. Cover a page with wrapping paper.

Continued on next page

68. Cut a door or window in your cover.
69. Insert a clock in a niche.
70. Add bottle caps. Show the tops or turn them over and glue pictures or words inside.
71. Add a paper doll.
72. Color a design with crayons, then apply a watercolor wash.
73. Color a page solid with a crayon, then scratch a design in the wax.
74. Cover a page with rows of rickrack, braid, lace, or a selection of trims.
75. Make a page about a single color, using a single color.
76. Use letter tiles to spell out a message or poem.
77. Burn page edges.
78. Color pages with nail polish.
79. Cover a page with pressed flowers or leaves.
80. Glue everything you've cut out of your book on one page.
81. Wrinkle craft paper, wet it, then brush with paint. Allow to dry. Use to cover pages or a cover.
82. Cover a page or book cover with burlap, vintage fabric, or vinyl tablecloth.
83. Add leather trim pieces or make a leather cover.
84. Glue the cover from a smaller book to the cover of a larger book.
85. Glue hardware items such as washers or nails to the cover.
86. Apply a faux metallic finish to pages or cover.
87. Tear or cut tissue paper into random-width strips. Glue them to pages or cover, overlapping the strips.
88. Apply hot glue squiggles. Let set. Rub with metallic paste.
89. Bind book with electrical wire.
90. Glue a computer circuit board to a page.
91. Make you own handmade paper from junk mail to use for collage.
92. Use a woodburning tool to embellish wood or leather pieces.
93. Spray paint pasta. Use as beads.
94. Draw a chalk picture. Mist lightly with water and allow to run.
95. Use dress pattern pieces for backgrounds.
96. Paint plastic wrap, then glue to pages.
97. Lay damp tea bags on pages to discolor spots. Try herbal teas like rose hip or chamomile for interesting colors.
98. Mist pages with water, then sprinkle on instant coffee granules to create age spots.
99. Make a collage with the same photo in five different sizes and colors.
100. Tie pages together with shoelaces.
101. Look around your house and find something you either like or don't care about. Add it to your pages.

Techniques for Decorating Book Pages

THIS SECTIONS SHOWS TECHNIQUES FOR DECORATING PAGES - RUBBER STAMPING, DECOUPAGE, ADDING COLOR, AND BURNING EDGES, PLUS NUMEROUS WAYS TO ADD EMBELLISHMENTS.

Rubber Stamping

Rubber stamping is an easy way to add artistic elements. You can find a wide array of stamps and inks to fit any style or theme. It's important to use the appropriate ink for the application; in the examples, the type of ink that works best is listed. *Tip:* If you have never stamped, practice on a scrap similar to your surface.

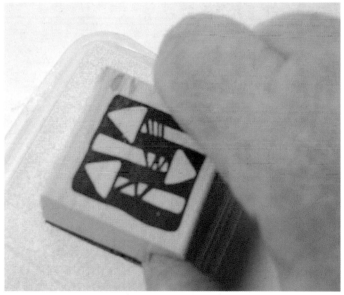

Inking a small stamp by pressing on an inkpad.

1. Press the stamp on the inkpad to evenly cover the raised surface of the stamp with ink.
2. Align the stamp on the surface and press down without rocking the stamp.
3. Remove the stamp by lifting it straight up.

Continued on next page

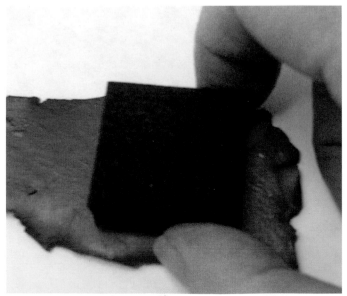

Pressing a small inked stamp on a surface.

Continued from page 33

To ink a larger stamp, place the stamp, rubber side up, on your work surface and dab the stamp with an inkpad. *Option:* Use a brayer to spread ink evenly across the surface.

You can place the surface to be stamped on the stamp and press or pick up the stamp and press it. To ensure good contact between the stamp and the surface, firmly walk your fingers across the stamp.

Embossing

Stamped images can be embossed to create raised designs.

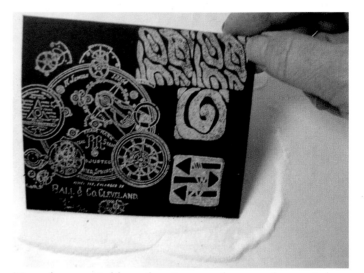

To emboss, sprinkle embossing powder over the wet ink and tap off excess powder. *Tip:* Do this over a sheet of paper to save the excess embossing powder.

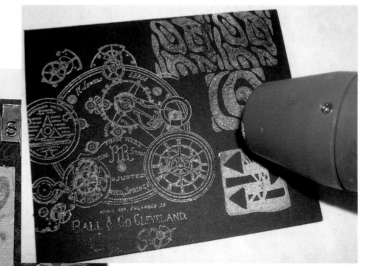

To create the embossed image, heat with a heat gun until the powder melts evenly.

Heat Setting: Some inks need to be heat set; others dry almost instantly. To heat set ink, hold a heat gun 2" to 4" above the surface for a few seconds.

Decoupage

The decoupage technique uses a glue-like medium to adhere a motif or cover a surface. Decoupage medium can be used to good effect to create a collage of flat materials like paper or fabric. It can also be used as a sealer.

There are a number of types of decoupage medium, from high gloss to matte finish. It's best to choose one and experiment - you want to be sure it won't turn sticky and ruin your pages. Separate decoupaged pages with sheets of wax paper until the medium has cured. *Tip:* If the medium does become sticky, try spraying a clear sealer over it, or buff with a small amount of floor wax.

1. Assemble the elements of your collage. Tear the edges for a soft, worn look or trim them with scissors.
2. Brush medium on both the surface and the back of the paper or fabric. *Tip:* Use an old telephone directory - place a cutout to be decoupaged on a page and brush with medium. Turn the page for each new piece.
3. Position the piece on the surface and smooth from the center outward, using either a slightly damp finger or a brush. Make sure all edges are well adhered.
4. Brush at least one more coat of decoupage medium over the top to seal.

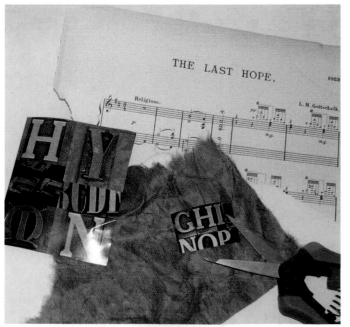

Assembling materials for a collage.

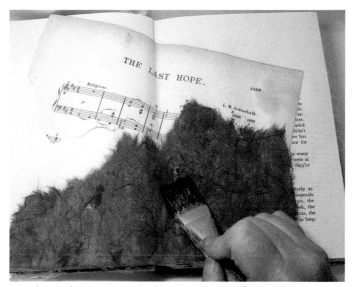

Brushing decoupage medium on the surface to adhere the layers.

Coloring

You can use inks, acrylic paints, watercolors, all kinds of colored pens, and even household items like coffee, tea, and bleach to add and alter color on pages. Interesting effects can be achieved by using two or more different coloring agents. To get started, pick two or three favorite colors and purchase them in different mediums.

Some coloring agents don't work over sealers or decoupage mediums. Take that into account when planning your pages.

Inks

Apply inks with a brush for a soft, stippled effect, or rub an inkpad directly on a page for embellishment. Ink from re-inkers can be brushed across a page, spattered, or sponged. You can use inks with rubber stamps or apply them with a brush through stencils. Any faux finishing technique (sponging, ragging, etc.) works with pigment inks.

Acrylic Paints

You can use the same techniques you use with inks to apply acrylic paints, but the coverage will be more opaque. Add glazes to acrylic paints to make them more translucent or give more working time. Use a liner brush to highlight details or create a painting on your pages.

Continued on next page

Continued from page 35

You can make a tool for pouncing inks or paints by cutting a square of upholstery foam (1" to 2") and shaping it into a ball.

Watercolors

Brush on watercolors for spots or drifts of color or as an all-over tint. Watercolors are ideal for creating a faux batik look or when you want a soft, matte glaze of color. For best results and to prevent the paper from wrinkling, use the least amount of water necessary for the effect.

Aqua crayons are watercolors in stick form. Use them as you would a wax crayon; you can feather out and shade the edges using a moist brush.

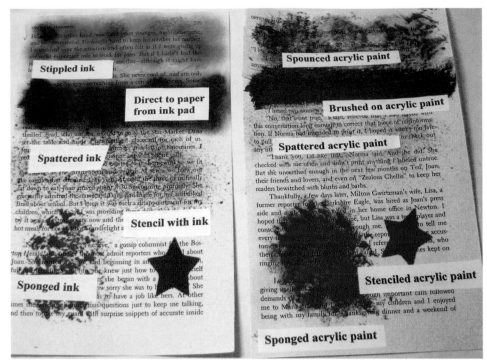

Acrylic paints give a more opaque look to your surface.

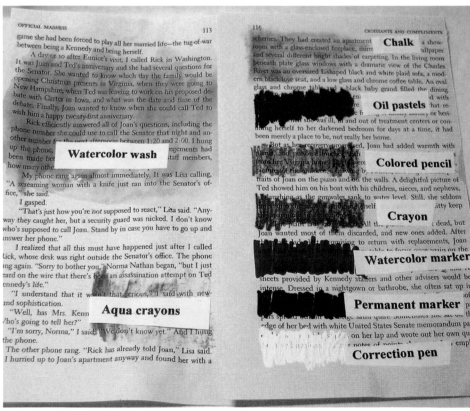

Pens, markers, colored pencils can be used in a variety of ways when decorating your book.

Other Coloring Options

Use pens, markers, colored pencils, chalks, pastels, and crayons to color stamped designs, black and white copies, or clip art. Or use them to highlight design elements, do lettering, or color entire backgrounds.

Coffee & Tea

Use coffee or tea as a stain to make new items appear old.

1. Dip plastic or fabric items in strong coffee or tea. Soak until two shades darker than desired shade.
2. Remove items and allow to dry before attaching to your page.

Bleach

Use the power of bleach to remove color. You can paint lines, dots, and images with bleach or stencil, sponge, or spatter bleach for additional textural effects. For best results, bleach must be fresh. If it sets out for a while, it loses its strength.

Here's a way to use rubber stamps with pigment ink and bleach to create an interesting design element.

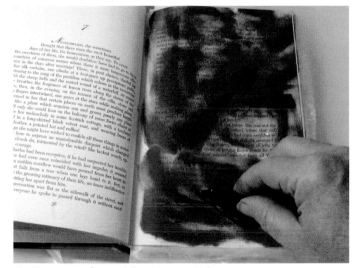

1. Coat a surface with pigment ink.

2. Place a folded paper towel on a foam or coated paper plate. Pour bleach on the paper towel to saturate.

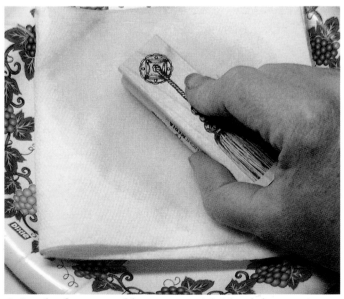

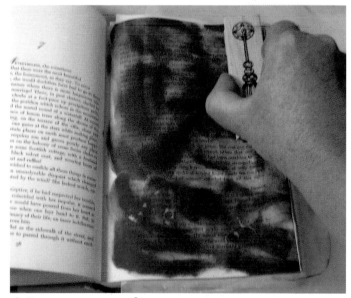

3. Load a foam or rubber stamp with bleach by pressing on the bleach-saturated paper towel.

4. Press stamp on surface.

Polymer & Air Dry Clay Embellishments

Making embellishments like tiles, medallions, tags, and charms from clay is very easy, and the clay is available in an array of colors. When working with clay, **always** follow the clay manufacturer's instructions for safe use and to obtain optimal results. You can cut the clay with a knife or with cookie or canape cutters. CAUTION: **Never** use a tool you have used with clay for food preparation.

TO MAKE A CLAY TILE:

1. Roll out or pat the clay to make a thin sheet slightly larger than the stamp. Use your hand, a clay roller, a rolling pin, or a pasta machine.

2. Rubber stamp the clay, using pigment ink.

3. Trim around the stamped image using a craft knife. Make holes, if desired, with an awl or a nail. Bake as directed or allow to air dry.

Ideas

- Make letter tiles by stamping the clay, then cutting out each letter individually.

- Use a couple colors of stamped clay to make layered medallions - simply stack clay pieces from largest to smallest.

- Cut tag shapes from clay, then press a brush handle through one end to make a hole. Let dry. Add strings or fibers.

- Make buttons, frames, or figures from clay.

Examples of stamped clay tiles.

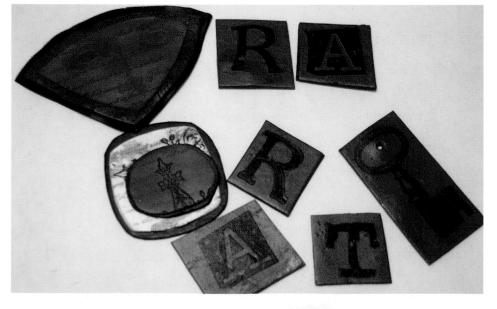

Transferring

Transferring an image from a piece of paper or your computer to your pages is a fun technique that allows great design possibilities. There are a number of products and methods for transferring images; each has advantages and disadvantages. For best results, your original must be very clear; if you are using toner copies, use freshly made ones. Following are some general categories with their attributes.

Decal-type Transfers

You can buy transfer paper for use with laser printers and copiers at office supply stores - you copy the image you want to transfer on the paper and follow the manufacturer's instructions for transferring. You can print images on clear sticker paper (also available at office supply stores) with an inkjet printer or copier, trim them, and press them on your pages. Both of these methods show the image well and are easy to do.

Iron-on & Fabric Transfers

You can buy specially designed fabrics and papers that can be printed with a computer printer or a copier. Follow the manufacturer's instructions precisely for best results.

Gel Medium

Use gel medium, which can be purchased where art supplies are sold, to transfer images from toner copies or magazines. It is available in matte and gloss sheens. This method is time consuming and difficult but gives a very fine, thin edge.

TRANSFER USING GEL MEDIUM

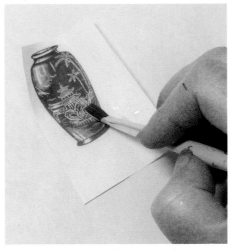

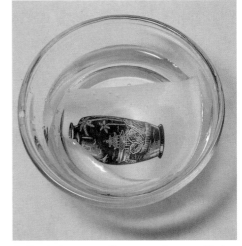

1. Brush an even, thin coat of gel medium over the image. Allow the medium to dry. Repeat five or six more times, brushing the medium in opposite directions (first coat horizontal, second vertical, third horizontal, etc.) Allow to dry eight hours after final coat.

2. Soak in water for ten minutes. Rub off backing paper with your fingers or a sponge.

3. Adhere the transferred image to the page with a thin layer of gel medium.

continued from page 39

Tape or Sticky Paper Transfers

Clear packing tape or clear matte sticky-back paper also can be used to transfer toner copies or magazine images. This method is inexpensive and easy, but the transferred image will have a thick edge. For a non-shiny look, mist with a matte spray sealer or brush with matte medium.

3. Place the taped image in water for about ten minutes.

1. Place the image you wish to transfer face up on a hard surface. Smooth tape or sticky-back paper over the image using a bone folder or old credit card.

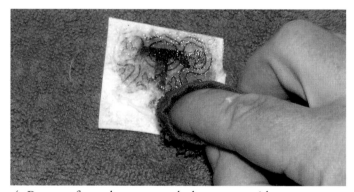

4. Remove from the water and place, paper side up, on your work surface. Gently rub the paper off the back of your image with your finger or a sponge. Allow to dry without touching. If, after drying, the image looks cloudy, re-moisten it, rub away any remaining paper, and let dry.

2. Trim the image with scissors or a craft knife.

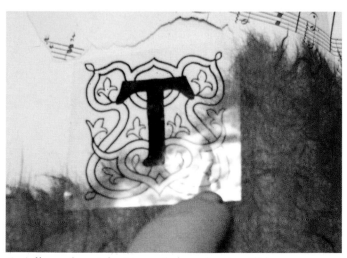

5. Adhere the sticky image (when dry, it will be very sticky) directly to your page.

TECHNIQUES

Inkjet Printer Transfers

Use this technique to transfer images printed by an inkjet printer or copier. With practice, this technique gives a very good impression of the original on a smooth surface. **Note:** The image will be reversed when it is transferred. If your image includes lettering, print it using the mirror function on your printer. This technique also works well on fabrics.

1. You will need an inkjet printer, printable transparency sheets, gel medium or fabric decoupage medium, a bone folder, and a brush.

2. Print the image(s) on a transparency sheet, following the transparency and printer manufacturers' instructions. Allow to dry. Cut image(s) from the sheet. Try out the design by placing it on your project.

3. Brush an even layer of gel medium or decoupage medium (an area the size of your transfer) on the project surface, then smooth with your finger. The medium should be slick and very smooth. (Otherwise, ridges in the medium might show through.)

4. Lay the transparency sheet, ink side down, on the medium. Press evenly with fingertips, and don't allow the transparency to slide around. Rub over transparency sheet with the side of a bone folder until the image is completely transferred. (You can pick up a corner to check your progress.) Complete this step within two minutes - if you don't, the medium will start to dry and adhere the sheet to the surface.

5. Peel up the transparency sheet to reveal the image.

Embossed Metallic Embellishments

Use this technique to add unique textured embellishments with the gleam of metal to your pages. After creating a raised image with a rubber stamp and embossing powder (as shown below) or hot glue (as shown in the Winter Page Spread in the Ideas section), rub the raised image with metallic paste.

SUPPLIES

Black cardstock

Rubber stamps

White pigment inkpad

Clear embossing powder

Rub-on metallic pastes (gold, silver, copper)

Heat gun

Paper towel or soft rag

Palette

INSTRUCTIONS

1. Use white pigment ink to rubber stamp a number of images close together on cardstock.
2. Emboss stamped images with clear embossing powder. (photo 1)
3. Squeeze a small dot of each metallic paste color on a palette. Working one color at a time, dip your finger in metallic paste and rub over the embossed image. (photo 2)
4. Buff entire card, using a paper towel or soft rag. (photo 3)

Photo 1 - Embossing the stamped images using a heat gun and embossing powder.

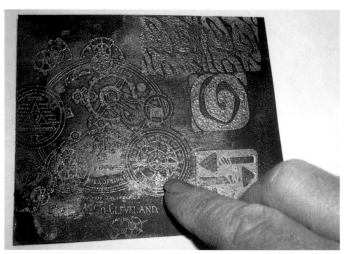

Photo 2 - Rubbing with metallic paste.

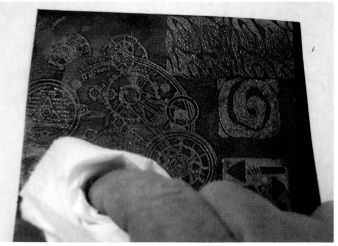

Photo 3 - Buffing with a paper towel.

Microscope Slide Embellishing

Glass microscope slides, adorned with metal leafing, ferns, transparencies, or rubber stamping, make great dimensional embellishments. See the Nature's Miracles book in the Ideas section.

SUPPLIES

2 glass microscope slides

3/8" wide self-adhesive metal tape (copper, gold, or silver)

Bits of metallic leafing

Small photocopies or transparencies

Bits of dried fern

Decoupage medium

Scissors

Small brush

Wooden spoon handle *or* small dowel

INSTRUCTIONS

1. Brush decoupage medium on one slide. Drop bits of metal leafing over the decoupage medium.
2. On the second slide, brush on a small amount of decoupage medium, place some dried fern on the slide, and dab with more decoupage medium. (photo 1) Allow both slides to dry completely.
3. Place transparency or photocopy on fern slide. Place metal leafing slide, metal leaf side down, on top of the fern slide. (You've formed a "sandwich" with the smooth glass outside and all added elements inside.)
4. Hold slides together with your fingers and wrap the edges with metal tape. (photo 2) Trim excess tape with scissors.
5. Press tape against glass with a wooden dowel or spoon handle. (photo 3)

Variation: Use a quick drying, permanent ink to rubber stamp images on glass slides.

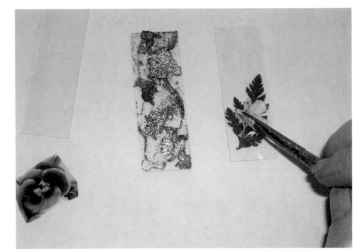

Photo 1 - Adhering the fern piece. (Slide with metal leafing is at left.)

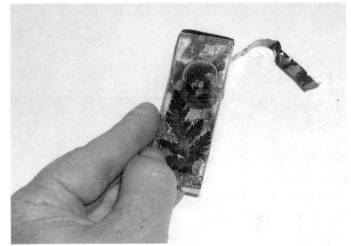

Photo 2 - Wrapping the edges of the slide "sandwich" with metal tape.

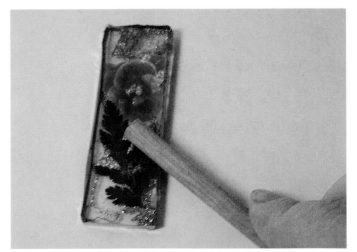

Photo 3 - Pressing the tape against the glass with a wooden dowel.

Stamped Spackle Embellishments

Stamped spackling compound provides the base for this interesting textural decoration. Paint the dried spackle to coordinate with your page or book cover. For an example, see the Decoupaged & Spackled Cover project in the Ideas section.

A stamped spackle embellishment.

SUPPLIES

Quick-drying spackling compound (available at hardware stores)

Mat board

Putty or palette knife

Rubber stamps (Choose ones with bold lines.)

Acrylic craft paints

Brushes

INSTRUCTIONS

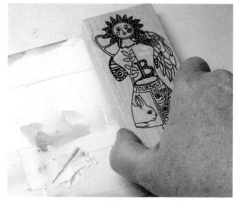

1. Cut mat board to size.
2. Spread spackle thinly over the mat board with a putty or palette knife.

3. Moisten the rubber area of the rubber stamp with water, then press firmly into the spackle. Wash spackle from rubber stamps immediately.

4. Allow stamped spackle images to dry completely.
5. Paint the stamped spackle with acrylic paints.

Crackled Stones (Dominos)

Crackled stone dominos are embellishments on their own, but they can be further embellished with solvent-based inks. Work in a well-ventilated area and be sure to protect your work surface, since these inks are permanent. For a faux stone look, try adding them to a page, in a niche, or to a book cover.

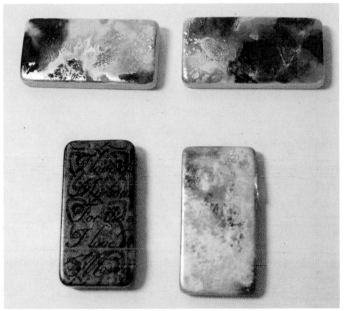

Examples of various faux stone dominos. You can use different ink and metallic pen colors or add rubber stamping on top.

SUPPLIES

Faux ivory dominos

Solvent-based inks, 2-3 colors (It's easier with re-inker bottled ink.)

Metallic marker (coordinating color)

Rubbing alcohol

3" square felt, any color

Disposable plate

INSTRUCTIONS

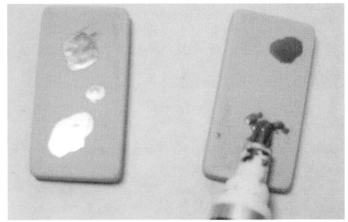

1. Dab a metallic marker in the color of your choice randomly on the flat sides of dominos in two or three places.
2. Place the felt square on a disposable plate. Mist with rubbing alcohol.

3. Drop dots of all inks on the felt pad.

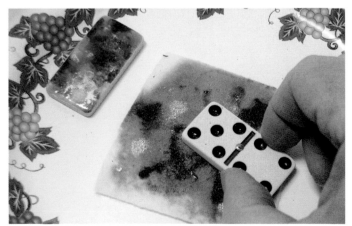

4. Press dominos on prepared felt pad, metallic ink side down. Let dry overnight.

Burnt Edged Papers

To make some papers unique, burn the edges. I like to use stick incense – it's easy to control. Note that some papers burn very quickly, and others burn much more slowly. Work in a well-ventilated area on a heat resistant surface where water is readily available.

SUPPLIES

Natural fiber papers without a lot of ink

Stick incense

Matches

INSTRUCTIONS

1. Light the incense, then blow out the flame. Allow about 1/4" of the incense to glow.
2. Lightly touch the glowing end of the incense to the paper edges. As the paper ignites, let it burn slightly, then blow out the flame.

Sealing

Many of the mediums used for altered books will need to be sealed to prevent pages from sticking together. Two common ways to seal pages are by using a spray-on acrylic sealer or applying a thin coat of acrylic floor wax.

Follow the manufacturer's instructions for application and recommendations for drying time when using a spray-on sealer. To use floor wax, brush a light coat across your page then buff with a soft rag.

You can also seal inks by heat setting or embossing. (See the section on Rubber Stamping.)

Protecting Pages

While I'm working on a book, I place pieces of baking parchment between the pages to allow them extra curing time while I continue to work.

When shipping or storing an altered book, it's a good idea to place wax paper or baking parchment between the pages. Use a sheet of bubble wrap if there are three-dimensional embellishments.

Altered Book Cover & Page Ideas

THE FOLLOWING PAGES SHOW-
CASE MANY TECHNIQUES,
STYLES, AND SPECIAL EFFECTS
YOU CAN TRY. SINCE MUCH OF
WHAT MAKES AN ALTERED
BOOK SPECIAL ARE THE PERSON-
AL ITEMS USED WITHIN THE
PAGES, YOU SHOULD FEEL FREE
TO SUBSTITUTE ANYTHING AT
ANYTIME. YOUR PAGES NEED
NOT BE CARBON COPIES OF THE
EXAMPLES. AS YOU WORK,
REMEMBER THE MOTTO OF
ALTERED BOOK ARTISTS,
"THERE ARE NO RULES!"

Watercolor Batik Pages

SUBTLE TONES AND HIGHLIGHTS ARE ACHIEVED ON THIS SPREAD BY THE USE OF A WATER-COLOR BATIK TECHNIQUE.

SUPPLIES

Base book - Sociology textbook, 8-1/2" x 11"

Watercolor paints - Red, yellow, green

Rubber stamps - Skeleton leaf, 2 geometric patterned squares, butterfly, dragonfly, background collage

Pigment inks - White, black

Clear embossing powder

4 silver skeletonized leaves

Black nylon screen, 5-1/2" x 4"

Feather butterfly, 4" x 3"

4 silver mini brads

Computer generated writing printed on yellow paper or text about butterflies

Tacky glue

Glue stick

Plain copy paper

TOOLS

Heat gun Brush

Iron Scissors

Awl

INSTRUCTIONS

1. Stamp both pages randomly using the skeleton leaf, geometric square, and collage stamps with white ink.

2. Sprinkle embossing powder on all stamped images before ink dries. Tap off excess powder. Hold heat gun 2" above page and melt powder until it is glossy.

3. Brush a thin coat of plain water across pages. Dip brush in yellow watercolor and brush across pages, adding paint and water as needed. Rinse brush. Apply green paint to one third of the pages. Rinse brush. Repeat with red paint, allowing colors to blend. Use photo as a guide for color placement. Allow pages to dry.

4. Place copy paper over pages. Iron over copy paper on a medium high setting until embossed images show on copy paper. (They will be shiny blobs roughly the size and shape of the embossed images.) Remove copy paper.

5. Ink dragonfly stamp with black ink and stamp across both pages. Re-apply ink for each stamping. Allow some dragonflies to run off the pages.

6. Stamp one butterfly on one page with black ink.

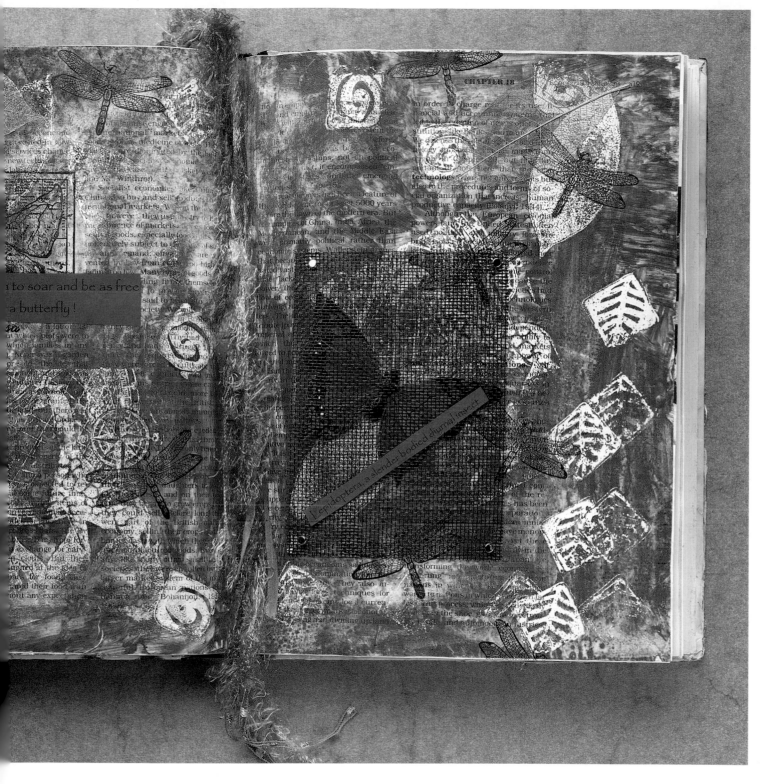

7. Smear a light coat of tacky glue on the backs of the skeletonized leaves and press on the pages.

8. Use tacky glue to glue feather butterfly opposite stamped butterfly.

9. Lay screening over butterfly. Push awl through corners of screening and book pages. Insert brad through hole made with awl then open brad wings on back of page.

Repeat on all corners.

10. Trim writing or text with scissors. Attach to pages and screening using a glue stick. ❏

Leaves of Nature

THESE PAGES SHOW
SEVERAL EXAMPLES OF
USING SIMPLE STITCHES
ON PAPER TO ADD
TEXTURE, INTEREST, AND
SPOTS OF COLOR.

By Chris Malone

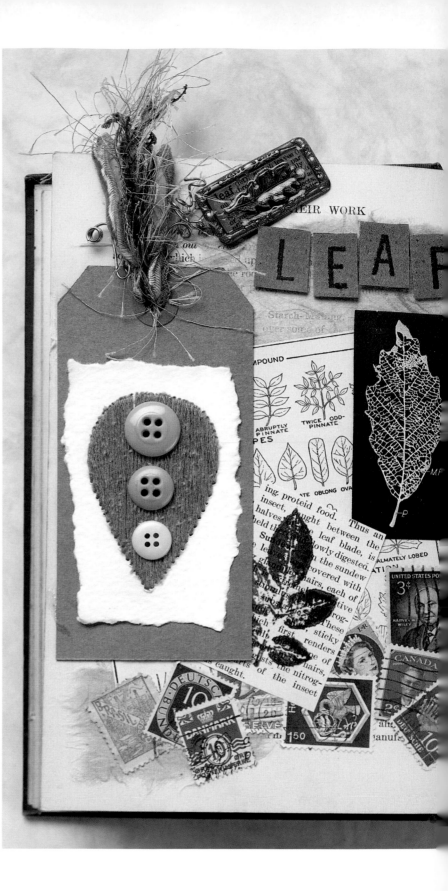

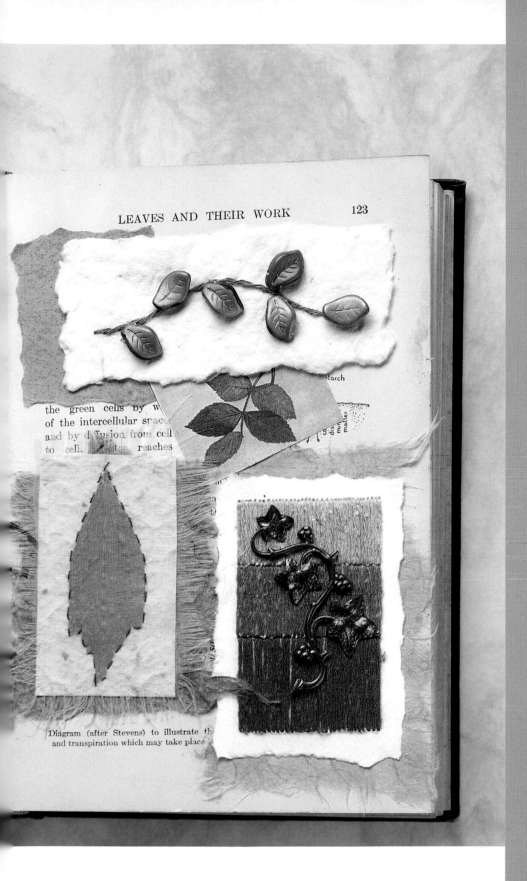

SUPPLIES

Scraps of watercolor paper and/or thick handmade paper

Scraps of tan, brown, and green papers (for background)

Rayon/silk fibers *or* six-strand cotton embroidery floss - medium green, dark green, 3 shades of brown

5 assorted fibers, 10" length

Brown tag, 2-1/2" x 4-3/4"

3 assorted buttons in graduated sizes

6 glass leaf beads

Pressed leaf, approximately 2-3/4" long

Ivory organza, 2-1/2" x 4"

Brass stem and leaf charm, 2-1/4"

Brass tag charm, 1-1/2"

Brass leaf charm, 1"

Brass 20 gauge wire, 8" length

Cutout dictionary description of "leaf"

Cutouts of leaves (old book or magazine)

Small piece of brown cardboard

Rubber stamp - Small leaf

Alphabet rubber stamp set, 1/2" high

Pigment inks - Dark brown, green

Clear embossing powder

8-10 assorted green postage stamps

Sewing thread - Ecru, brown

ADHESIVES

Tape

Glue stick

Fabric glue

Dimensional adhesive

TOOLS

Embroidery and sewing needles

Heat tool

Scissors

Pencil

Ruler

Cotton swab

continued from page 51

INSTRUCTIONS

Read the Tips before you begin.

Button Leaf:

1. Tear a 2" x 3" rectangle from watercolor or handmade paper.
2. Use pencil to lightly draw a leaf shape in center of paper.
3. Thread needle with fiber or six strands of embroidery floss and come up from back of paper at point of leaf. Make a long straight stitch to bottom center of leaf. Come back up again beside first stitch on pattern line. Continue to make satin stitches to cover leaf shape, following pattern lines.
4. Use fabric adhesive to glue three buttons to leaf and to glue watercolor paper to brown tag.

Beaded Leaf Vines:

1. Tear a 1-3/4" x 4" rectangle from watercolor or handmade paper.
2. Lightly draw a curved line across paper.
3. With dark green fiber or floss, stem stitch along pattern line.
4. Sew leaf beads to stem with doubled ecru sewing thread and sewing needle.

Pressed Leaf:

1. Cut a 1-3/4" x 3" rectangle from tan paper.
2. Use small dots of fabric adhesive to glue pressed leaf to paper.
3. Place organza scrap over leaf and paper.
4. Using a single strand of brown sewing thread and sewing needle to make small running stitches around leaf, sewing very close to leaf and through fabric and paper.
5. Cut uneven edge on organza and pull threads to fray edges.

Leaf Charms:

1. Tear a 2-1/4" x 3-1/2" rectangle from watercolor or handmade paper.
2. Use pencil and ruler to lightly draw four 2" lines across the paper. (The space between the lines is 7/8", 1", and 1-1/8", respectively.)
3. Satin stitch top band with light tan fibers or floss, middle band with medium brown, and bottom with darkest brown.
4. Use fabric adhesive to glue stem and leaf charms to top of stitchery.

Brass Tag Charm:

1. Cut dictionary definition of "Leaf" to fit brass tag charm. Glue inside frame.
2. Use dimensional glaze to glue small leaf charm to paper. When set, apply glaze to entire inside section of charm. Let dry.
3. Attach charm to wire; twist to hold. Thread other end of wire through hole in paper tag; twist together and curl wire ends. Attach fibers to tag.

Stamped Leaf:

1. Apply green ink to leaf stamp and stamp on a small rectangle of print from another page in book.
2. Emboss with clear powder.

Alphabet Rectangles:

1. Stamp letters for "LEAF" on brown cardboard with dark brown ink; emboss with clear powder.
2. Cut apart into small rectangles.

Assembly:

1. Tear pieces of green, tan, and brown papers to use as background for completed motifs.
2. Using project photo as a guide, arrange papers, leaf cutouts, and stitched and stamped pieces. Overlap postage stamps on one page for color.
3. When satisfied with arrangement, glue in place. Use glue stick for paper backgrounds and fabric adhesive for heavier pieces. ❏

RUNNING STITCH

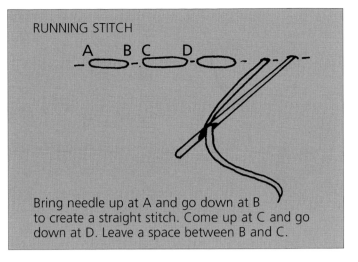

Bring needle up at A and go down at B to create a straight stitch. Come up at C and go down at D. Leave a space between B and C.

SATIN STITCH

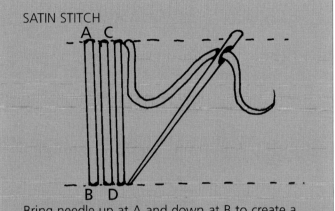

Bring needle up at A and down at B to create a straight stitch. Bring needle up at C and down at D, making another straight stitch near the previous one. Repeat.

STEM STITCH
(or Outline Stitch)

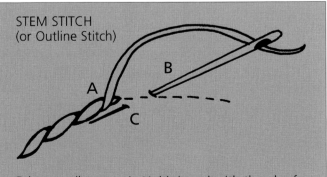

Bring needle up at A. Hold thread with thumb of other hand. GO down at B and come up at C. Pull thread through. Continue making a stitch and coming up at a short distance back.

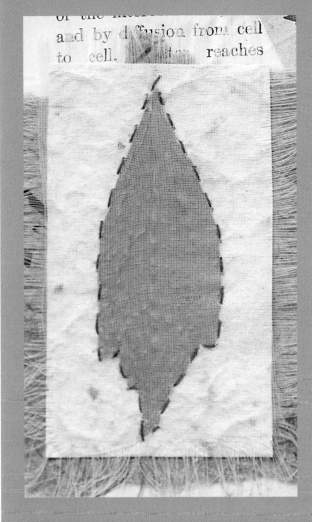

Tips

- Paper tears easier if first dampened with water and a cotton tip swab along the tear line.

- Stitching on paper is unforgiving. It is easier and more accurate to make a hole for the needle from the front of the paper, then bring the needle through the pre-made hole.

- Instead of using knots in the fiber, hold about 1/2" on the back with a small piece of tape.

- When making stitches close together, the paper may tear between the holes. A piece of tape on the back will hold the stitches in place until the completed piece is glued to the page.

Beaded Edging

WHIP STITCHING BEADS TO PAGE EDGES USING WIRE, BEADING THREAD, OR FIBERS CAN ENHANCE A PAGE SPREAD WHILE ADDING DIMENSION ALONG THE OUTER EDGES. FEEL FREE TO USE CHARMS, COINS, OR FOUND OBJECTS THAT RELATE TO YOUR PAGES ALONG WITH THE BEADS. THIS METHOD IS ALSO ANOTHER WAY TO MAKE A BLOCK OF PAGES AS YOU ATTACH THE BEADS.

SUPPLIES

Variety of small- to medium-size beads

28 to 24 gauge wire

TOOLS

Awl

Scissors or wire cutters

Round nose pliers

INSTRUCTIONS

1. Using the awl, poke holes along outer edges of three or more pages. The holes may be evenly spaced or randomly placed but should be no more than 1/2" apart.
2. Cut wire twice the length of area you are going to bead. (Example: Cut 16" for an 8" page.)
3. Attach wire by running through holes at top of page. Leave a 3-4" wire tail. Twist tail around long wire length close to page edge.

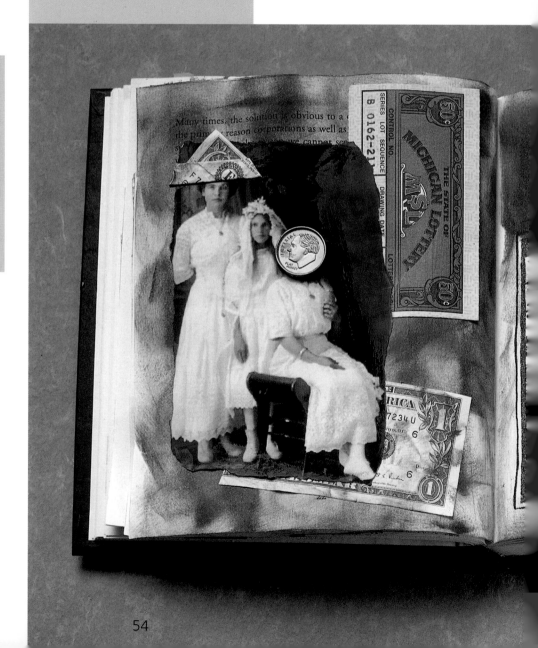

This photo shows holes for beading made on the edges of the pages on both sides.

This photo shows a beaded edge on the pages at left and the beginning of the beading on the pages at right.

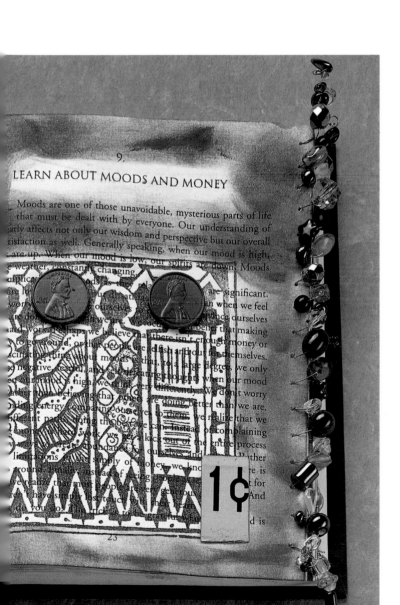

4. Add small beads to tail wire. Twist a tight loop on end of wire using pliers to secure beads. Curl wire between beads by wrapping wire around awl.

5. Add beads to long wire. Loop wire over edge of pages and into next hole. Repeat for all holes, adding beads as you go.

6. Add beads at the end of the wire, securing beads with a tight loop. ❑

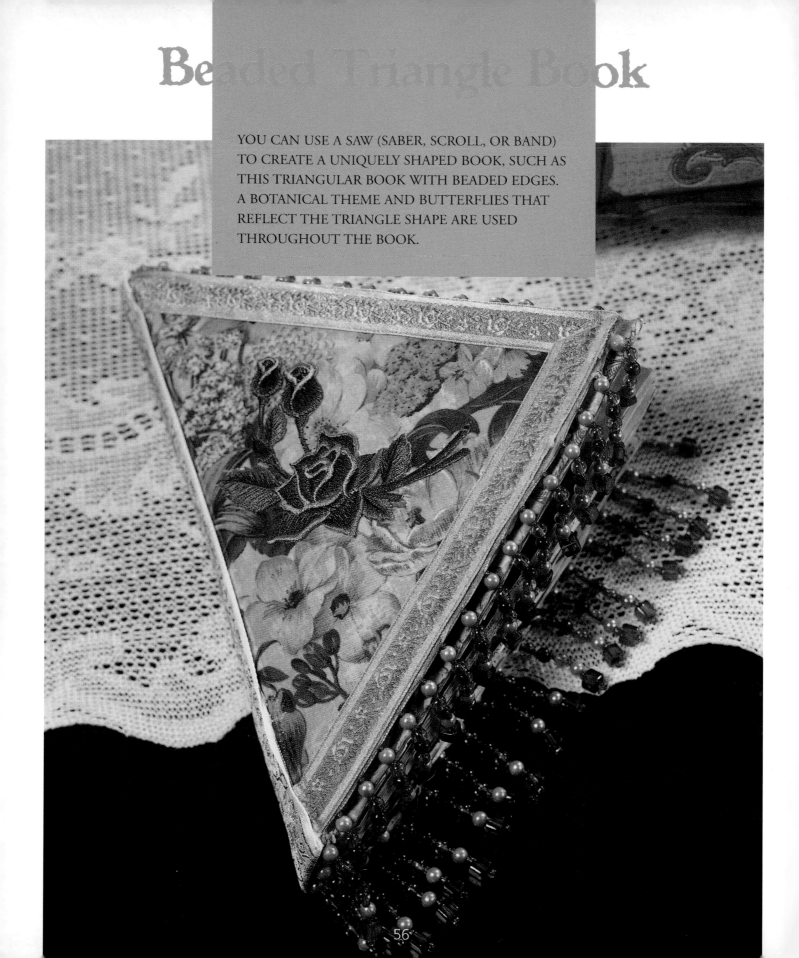

Beaded Triangle Book

YOU CAN USE A SAW (SABER, SCROLL, OR BAND)
TO CREATE A UNIQUELY SHAPED BOOK, SUCH AS
THIS TRIANGULAR BOOK WITH BEADED EDGES.
A BOTANICAL THEME AND BUTTERFLIES THAT
REFLECT THE TRIANGLE SHAPE ARE USED
THROUGHOUT THE BOOK.

Shaping the Book

SUPPLIES

A very sturdy book with approx. 300 pages

TOOLS

Saber, scroll, or band saw with a fine-tooth blade

4 clamps, 2 for each cut side

Ruler

Marker, any color that will show well on the cover

INSTRUCTIONS

1. Use the ruler and marker to mark the center on the edge of the cover. Draw lines from each end of the spine out to the center mark.
2. Clamp the sides together tightly, using at least two clamps on each side.
3. Cut the book along the marked lines, using care to keep the lines straight. Blow away the dust as you work.
4. Make blocks of pages to create eight evenly spaced book sections. (Refer to General Instructions for how to make block.) ❑

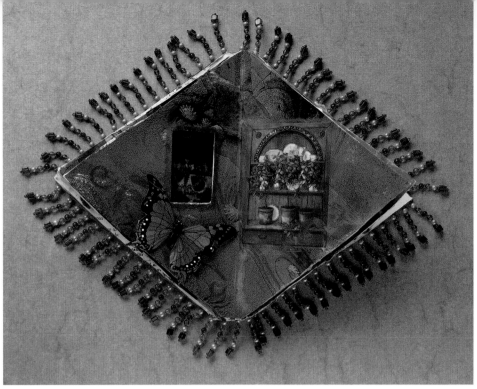

Inside the book.

Decorating the Cover

SUPPLIES

Fabric, 1" larger on all sides than cover opened out flat

Beaded trim, 1" longer than outside measurement of cover

Trim, 3/4" wide, 1" longer than outside measurement of cover

Trim, 1-1/2" wide (for spine), 1" longer than spine

Embroidered applique

Decoupage medium

Fabric glue

TOOLS

Scissors

Measuring tape

Brush (for applying decoupage medium)

INSTRUCTIONS

1. Open book so both covers are exposed.
2. Brush decoupage medium over cover and on back of fabric.
3. Smooth fabric on cover, pushing fabric down along spine. Close before medium sets to be sure fabric is not too tight. Let dry.
4. Apply two more coats of decoupage medium over fabric, allowing each to dry before applying the next.
5. Using fabric glue, apply trims to cover. Glue beaded trim around edges, overlapping the ends. Glue 3/4" trim on top of beaded trim. Glue 1-1/2" trim on spine, turning raw edges under at top and bottom.
6. Glue applique to front cover. ❑

Botanical Clipping Spread

INSTRUCTIONS

1. Adhere three pages to the inside cover on the left. Make a six-page block on the right.

2. Stamp words on some of the taupe paper. Tear remaining paper into blocks of various sizes.

3. Arrange layers of taupe paper, botanical clippings, the butterfly, and the stamped words.

4. Attach to pages with decoupage medium. Allow to dry.

5. Seal with another coat of decoupage medium. ❑

SUPPLIES

Paper with foliage print (for background)

Sheet music

5 butterflies of various sizes (cut from decoupage paper) Bust of woman (cut from decoupage paper)

Decoupage medium

TOOLS

Brush

Scissors

Lady Butterfly

INSTRUCTIONS

1. Make six- to eight-page blocks for both sides of spread.
2. Decoupage background paper over both pages. Allow medium to dry. Trim edges even with book pages, using scissors.
3. Tear sheet music into rectangles.
4. Arrange papers to create collage.
5. Decoupage all papers to the background. Let dry.
6. Seal both pages with another coat of decoupage medium. ❏

SUPPLIES

Nature-themed clippings (from an old dictionary)

Bird and butterfly (cut from decoupage papers)

Bits of handmade paper

Pressed leaves

Small stone

Feathers or other natural materials such as shells

Decoupage medium

Tacky glue

TOOLS

Brush

Scissors

Niche cutting tools (See the General Instructions)

Dictionary Niche Spread

INSTRUCTIONS

1. Plan niches to surround the stone or other natural materials and six-page blocks behind each niche. Glue blocks.

2. Cut niches. Glue the six-page blocks to the backs of pages with cutout niches.

3. Tear handmade paper.

4. Arrange all papers and pressed leaves on pages to make collage.

5. Use decoupage medium to adhere papers in place.

6. Use tacky glue to adhere materials in niches. ❏

Pressed Flowers

SUPPLIES

Sheet of cold pressed watercolor
 paper

Tube watercolor paints - Sap
 green, raw sienna, cadmium
 yellow

Dry fern fronds and leaves

Old letter (or photocopy)

Pressed pansies and ferns

Decoupage medium

TOOLS

Brush

Small mixing container such as a
 plastic cup

INSTRUCTIONS

1. Make six to eight-page blocks for
 both sides of spread.
2. Place watercolor paper on a flat sur-
 face. Mix a dot of each watercolor
 paint in a mixing container with
 1/4 cup water. Mix in one more dot
 of sap green.
3. Dampen watercolor paper by brush-
 ing with a light, even coat of water.
 Pour paint mix on watercolor paper.
4. Place ferns and leaves in wet paint,
 making sure they touch the paper.
 Allow paint to dry on flat paper
 overnight. Remove ferns and leaves,
 leaving an impression.
5. Decoupage watercolor paper to
 cover both pages. Allow to dry. Trim
 edges even with pages, using scissors.
6. Tear letter into a rectangle.
 Decoupage as shown in photo.
7. Arrange, then decoupage pressed
 pansies and ferns. *Tip:* To decou-
 page fragile items, brush a coat of
 medium on page, then gently place
 items on medium. Allow to dry.
8. Gently dab decoupage medium over
 pressed items. Allow to dry. Repeat. ❏

Quotes visible in the artwork:

*I do not think I will ever see
A poem as lovely as a tree.*
Joyce Kilmer

*...rtheless, it means much to have loved,
...ave been happy, to have laid my hand on
The living garden, even for one day.*
Jorge Luis Borges

*Keep love in your heart.
A life without it is like a
Sunless garden when the
Flowers are dead.*
Oscar Wilde

SUPPLIES

2 butterfly transparencies

Rubber stamp - Floral background

Pigment inkpad - Sienna

Rose-printed tissue paper

Garden quotes (computer
generated or from a book)

Bits of handmade paper

Pressed ferns and flower

Decoupage medium

Double-sided tape

TOOLS

Brush

Window cutting tools (See the
General Instructions.)

Scissors

Butterfly Transparency and Window Pages

INSTRUCTIONS

1. Make six- to eight-page blocks for both sides of spread.

2. Cut a window in right page block that is slightly smaller than the largest transparency.

3. Stamp pages using floral stamp and sienna ink. Allow ink to dry.

4. Tear rose tissue paper and handmade papers.

5. Arrange and decoupage papers, including quotes, to pages.

6. Gently decoupage ferns and flowers to pages. Allow to dry. Topcoat with more medium.

7. Use double-stick tape to adhere transparencies to pages. ❑

SUPPLIES

Print of nature scene (for
 background)

Clipping of window with topiaries

Stencil - Scrolling vine

Gold metallic marker

Feather butterfly

Decoupage medium

Tacky glue

TOOLS

Scissors

In the book, this collage follows the
Butterfly Transparency collage,
pictured opposite. You can see the
transparency on the page at left.

Garden Window

INSTRUCTIONS

1. Make a second six- to eight-page
 block on the right side, opposite the
 window page.

2. Decoupage background paper across
 both pages but not over the window.
 Allow to dry. Trim paper edges even
 with pages, using scissors.

3. Decoupage the window with topiaries
 clipping to the right page. Brush a
 coat of decoupage medium over

both pages, avoiding the window
area. Allow medium to dry.

4. Outline the window and topiary
 clipping with the gold marker.

5. Position the vine stencil on the page.
 Holding firmly, dab gold marker
 over the stencil opening, using an up
 and down motion. Remove stencil.

6. Remove wire from feather butterfly.
 Glue butterfly to page, using tacky
 glue. ❏

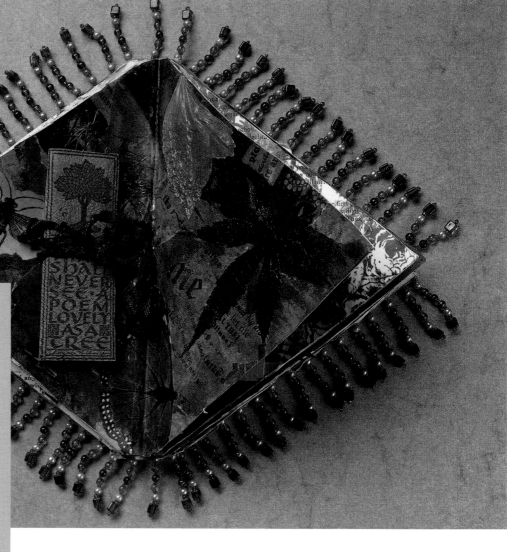

SUPPLIES

Either:

Photocopy of nature-theme
 collage

or

Nature themed clippings,
 handmade papers, brown kraft
 paper, strips of green leather,
 and computer generated
 phrases

plus

Butterfly (cut from decoupage
 paper)

Taupe paper

Pressed leaves

Tan leather, 5" x 5"

Rubber stamp - Tree poem

Pigment inkpad - Sienna

1 yd. autumn-toned fiber

Decoupage medium

Double stick tape

TOOLS

Brush

Scissors

Nature Collage

INSTRUCTIONS

1. Make six- to eight-page blocks for
 both sides of spread.
2. Decoupage photocopy of previously
 made collage to pages *or* create a
 collage. Allow to dry, then trim
 edges even with pages using scissors.
3. Decoupage pressed leaves and but-
 terfly to background.
4. Stamp tree on right half of tan
 leather piece. Set aside to dry.
5. Either print on a computer or write
 by hand, the tree poem on taupe
 paper, keeping lines no longer than
 4" and allowing a 1" space at the top.
6. Trim poem paper to 4-1/2" wide. Fold
 back 3/4" at top. Fan-fold the re-
 maining paper, making 1-1/2" folds.
7. Press double-stick tape along top
 fold. Peel off backing, then press on
 the center wrong side of tree-
 stamped leather. Fold leather around
 poem and tie fiber around to hold.
8. Apply two rows of double-stick tape
 to unstamped back of leather. Press
 to page. ❏

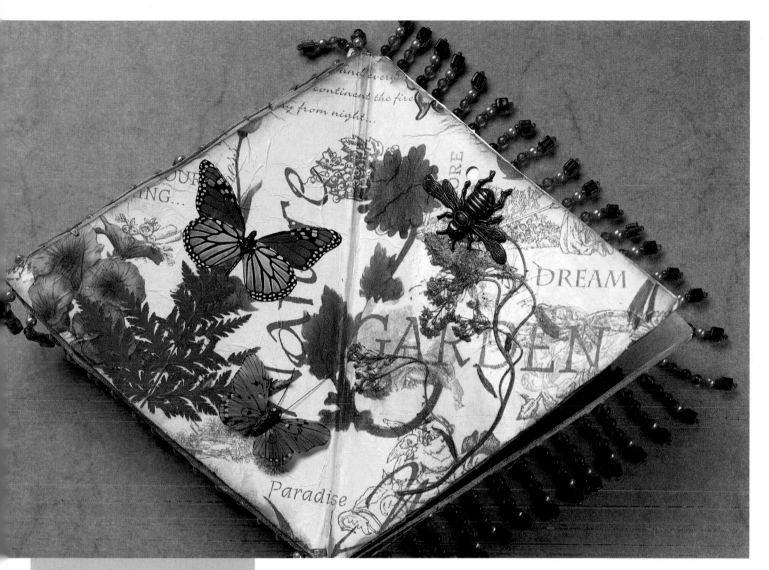

SUPPLIES

Garden-theme tissue paper

Butterfly (cut from decoupage paper)

Pressed flowers and ferns

Feather butterfly

Brass bee charm

Decoupage medium

Tacky glue

TOOLS

Brush

Scissors

Flight of Nature Page Spread

This is the inside of the back cover.

INSTRUCTIONS

1. At end of book, make two six- to eight-page blocks and glue right block to inside cover.
2. Decoupage tissue paper on both pages. Topcoat tissue with another coat of decoupage medium. Allow to dry, then trim edges even with pages, using scissors.
3. Gently decoupage pressed ferns and flowers to pages. (Apply a layer of medium to pages, place pressed items in medium, and allow to dry.) Dab medium over top of pressed items.
4. Decoupage paper butterfly to page.
5. Remove wire from feather butterfly. Use tacky glue to attach brass bee and feather butterfly to pages. ❑

Fish & Beads Pages

YOU CAN EASILY ADD TEXTURE, DIMENSION, AND SHIMMER
TO YOUR PAGES WITH DOUBLE-STICK TAPE AND TINY
HOLELESS BEADS. THIS ADDED LAYER ALLOWS THE
UNDERLAYERS TO SHOW THROUGH. IF YOU WANT MORE
BACKGROUND DETAIL TO SHOW, USE CLEAR BEADS.

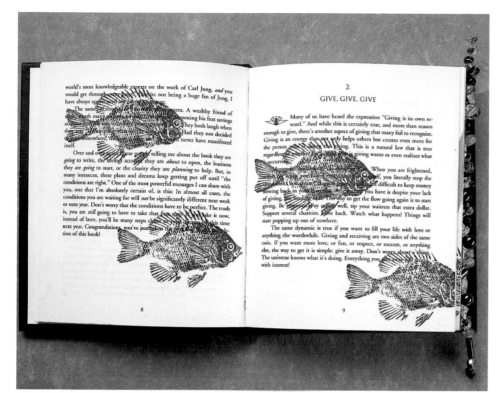

Photo 1. Pages stamped with fish motifs.

SUPPLIES

Rubber stamps - Fish, border

Inkpads - Black, sea green

Extra-sticky double-sided tape

Tiny holeless beads - Blue, green

TOOLS

Non-stick scissors *or* scissors and
rubbing alcohol (to remove
adhesive residue)

Tray *or* sheet of paper (to gather
excess beads)

INSTRUCTIONS

1. Make six- to eight-page blocks of
pages.
2. Stamp fish motifs on pages with
black ink. (photo 1)
3. Stamp border motifs on pages with
sea green ink.
4. Apply double-stick tape to pages.
Trim as needed with scissors. Leave
backing on tape (this tape had red
backing) while you press tape in
place. (photo 2)
5. Place book on a tray or on a sheet
of paper. Peel backing from tape.
Sprinkle beads over pages, pressing
them on the tape. Return excess
beads to the container. ❑

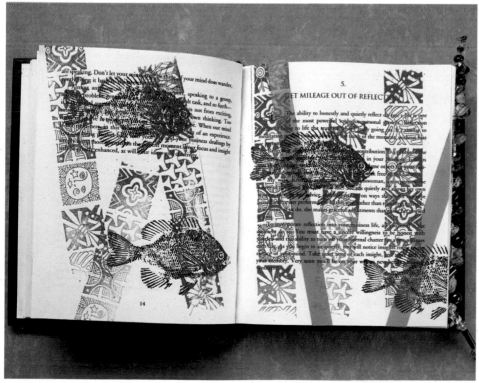

Photo 2. Pages stamped with fish and border motifs; double-stick tape applied to
pages on right in preparation for adding beads.

Photo Scrapbook Pages

THIS SECTION SHOWS A NUMBER OF TECHNIQUES - USING COLORED PENCILS ON PHOTOCOPIES, MAKING A COLLAGE SHEET MINI-BOOK, USING COLLAGES AS TIP-INS. (TIP-INS ARE PAGES THAT ARE MADE SEPARATELY AND GLUED OR "TIPPED" IN.) WHEN NONE OF THE BOOK'S TEXT IS BEING USED AS A BACKGROUND, IT IS EASIER TO WORK OUTSIDE THE BOOK. MINI-BOOKS AND TIP-INS ARE POPULAR IN ROUND ROBINS, SINCE EVERYONE CAN WORK ON A THEME AT THE SAME TIME, THE SHIPPING CHARGES ARE LESS, AND THE BOOK DOES NOT SUSTAIN AS MUCH WEAR AND TEAR.

SUPPLIES

Blue photo paper *or* cardstock to cover both pages

Sheet of lighter blue cardstock

Blue willow pattern paper napkin

Photographs

Photocopies of vintage coloring book pages

Text torn from another book

Miniature playing card, 2-1/4" x 1-3/4"

Computer and printer *or* black pen for writing

Gel medium, matte

Colored pencils

Gum art eraser

Glue stick

Bleach

TOOLS

Scissors

Craft knife

Metal straight edge

Brush

Cutting mat

INSTRUCTIONS

1. Measure and, if needed, trim blue paper or cardstock to fit both pages.
2. Brush bleach on photo paper with a brush to form frames on both pages, using photo as a guide. Allow to dry.
3. Make black and white photocopies of your photographs. For more elaborate coloring with pencils, make lighter, poorer quality copies. Make a few good quality black and white copies for contrast.
4. To make the mini book, cluster better copies on a scrap of paper, close together or slightly overlapping. Add edges torn from patterned napkin to fill gaps. Copy this photo montage at 60% for your mini book.
5. Color the copies, starting with the lightest color first, then adding darker tones to shade. Use a gum eraser to lighten areas for highlights.
6. Trim colored copies, using scissors.
7. Print words on lighter blue cardstock, using a computer printer. *Option:* Write with a pen.

Continued on page 70

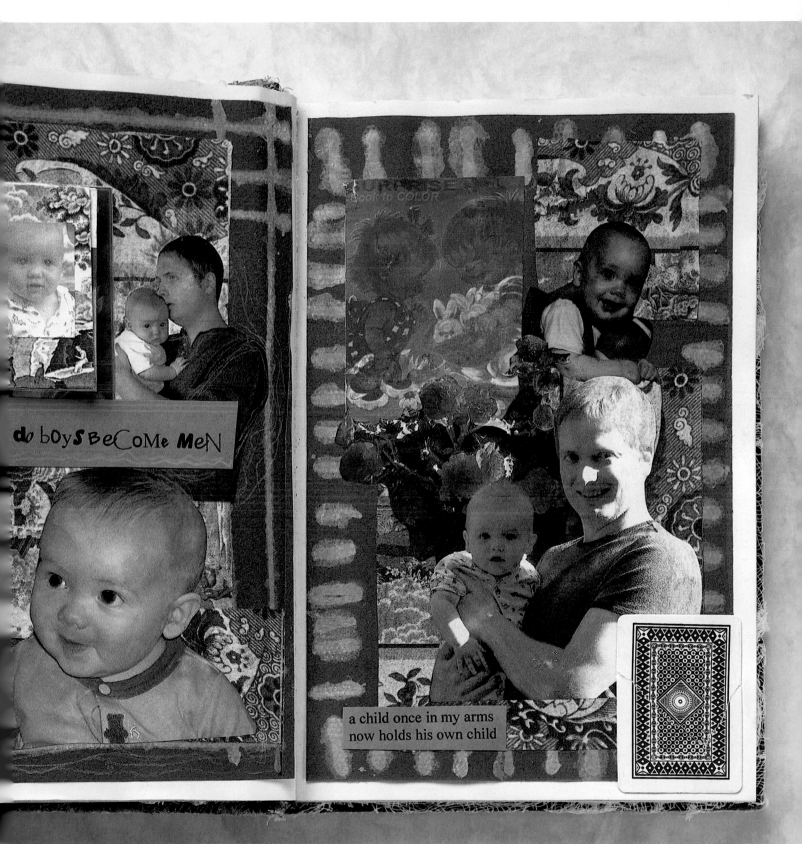

do bOyS BeCoMe MeN

a child once in my arms
now holds his own child

Photo 1. The mini book collage.

Photo 2. Cutting a slit.

Photo 3. Folding.

Photo 5. The folded mini book.

Photo 4. Folding to make pages.

continued from page 68

8. Trim around lettering with scissors.
9. Separate napkin plies and set aside plain layers.
10. Arrange papers except mini book on bleached paper to make collages, starting with the napkin print and ending with the printing and playing card.
11. Cover collages with larger sheets of paper, hold tight, and turn over. (This gives the proper order for attaching.)
12. Adhere papers to create collage, using gel medium. Allow to dry.
13. Cover backs of both pages generously with gel medium and press on book pages. Smooth pages.
14. Trim mini book collage to a smaller rectangle. *Note:* Refer to photos 1-5 for folding. Book is shown folded on the photograph side for reference; you should fold with the white (back) side up. (photo 1)
15. Fold mini book collage in half lengthwise. Open flat and cut a slit on the fold line from the center within 1/4" of edges. (photo 2)
16. Fold collage along first fold line, then fold in half crosswise. Open crosswise fold and fold right end into crosswise fold. (photo 3)
17. Fold left side into center, then open. Bend fold on back of slit in opposite direction. Push right end into center. (photo 4)
18. Gently push in along fold lines to form a rectangular shaped book. (photo 5)
19. Attach a piece of napkin and a small trimmed photocopied photograph to the front of mini book with gel medium. Attach the mini book to the page with gel medium spread onto the page directly behind the cover. Pull on one corner of book and collage sheet opens up for display. ❑

Bead Collage

TRY USING BEADS LEFT OVER FROM OTHER PROJECTS TO CREATE A COLLAGE. THIS TECHNIQUE WAS INVENTED BY TRACIA WILLIAMS, A MEMBER OF MY ALTERED BOOK GROUP. ALL THE GROUP MEMBERS LOVE IT. TO MAKE A BEADED COVER, FIRST CHOOSE A THEME, THEN FIND A PHOTO TO FIT YOUR THEME AND DECIDE ON A TITLE.

SUPPLIES

Beads of various sizes and colors, including alphabet beads (for the title)

Seed beads

Tiny holeless beads - Silver, blue

Charms, watch parts, coins, or metal findings

Photocopy of photograph

Dimensional adhesive or dimensional fabric paint

Decoupage medium

TOOLS

Scissors

Tray *or* sheet of paper (to gather excess beads)

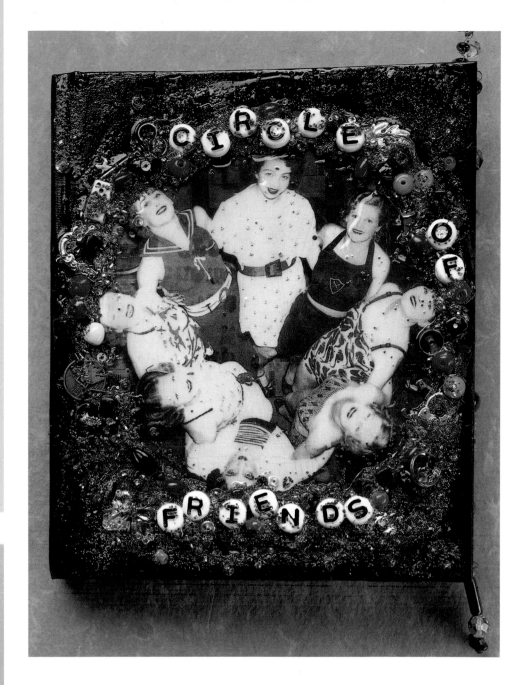

INSTRUCTIONS

1. Adhere photo to cover of book with decoupage medium. Let dry.
2. Adhere alphabet beads with dimensional adhesive around photo to spell title.
3. Randomly adhere larger beads and charms or other metal pieces around the photo with dimensional adhesive.
4. Squeeze dimensional adhesive around all the embellishments you've applied. Randomly sprinkle with seed beads. Tap off excess beads on a tray or a sheet of paper.
5. Repeat step 4 with tiny holeless beads. Let dry. ❏

Boys to Men

FOUR GENERATIONS OF MALE BABIES IN ONE FAMILY ARE REPRESENTED ON THESE PAGES. MONOGRAM LETTER RUBBER STAMPS, A SMALLER ALPHABET STAMP, AND VARIOUS SAYING STAMPS WERE USED TO PERSONALIZE.

SUPPLIES

Photocopies of family photographs

Dye-based inkpad - Mustard

Pigment inkpad - Black

Rubber stamps - Large alphabet set with numbers, sayings ("Love," "It's a boy"), symbols (hand prints, baby booties)

Wood tile letter stickers to spell out b-o-y-s and m-e-n

Decoupage medium

Ivory trim (enough to edge pages)

Fabric glue

Decoupage medium

TOOLS

Scissors

Brush

Optional: Heat gun

INSTRUCTIONS

1. Rub mustard-colored inkpad directly on pages. Allow ink to build up around edges and randomly across pages. Allow to dry. *Option:* Heat set with a heat gun.

2. Tear around edges of photocopies. Arrange photocopies on pages, starting with larger ones, then adding smaller photos, slightly overlapping.

3. Decoupage photos to pages. Smooth in place. Topcoat with decoupage medium. Allow to dry completely.

4. Using black ink, stamp family monogram, number of generations, and the number "2" on pages.

5. Stamp sayings and symbols on pages. Allow ink to dry. *Option:* Heat set.

6. Cut out and stick letter tiles on page.

7. Glue trim around page edges using fabric glue. Allow glue to dry completely before closing book or working on next set of pages. ❏

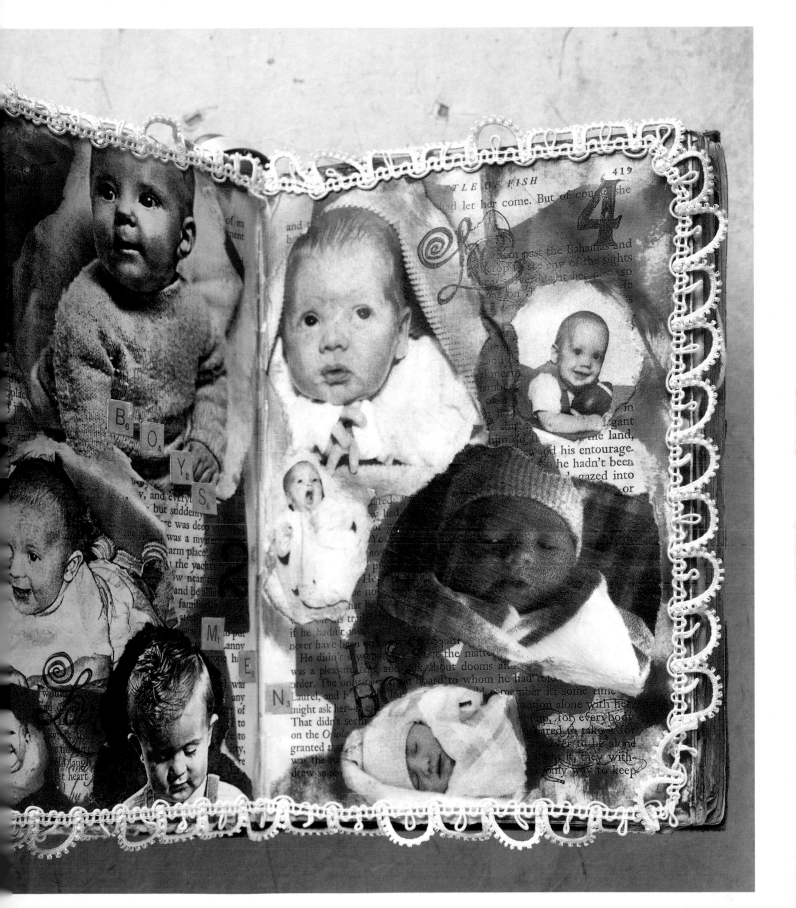

VINTAGE-THEMED COLLAGE PAGES THAT INCLUDE LACY TRIMS AND SEPIA-TONED PHOTOGRAPHS ARE ENCASED WITH A COVER THAT ALSO HAS AN AGED LOOK, COURTESY OF A FAUX RUST FINISH THAT OBSCURES THE BOOK'S ORIGINAL COVER.

Faux Rusted Metal Cover

SUPPLIES

Hardcover book with sturdy
 spine, 5-1/2" x 8-1/2"

Slide holder

Metal keyhole escutcheon plate

8 foam dots

Iron metallic paint

Rusting solution

Matte acrylic sealer

Solvent-based adhesive

TOOLS

Brush, 1-2"

Plastic wrap

INSTRUCTIONS

1. Wrap book pages in plastic to protect them. Open book flat so you can work on both covers and the spine at the same time.
2. Dab solvent-based adhesive on the backs of the slide cover and escutcheon plate and press on front cover.
3. Stick foam dots at corners of covers and at top and bottom of spine.
4. Brush a light, even coat of iron paint over entire cover, including edges. Let dry. Apply two more coats. Let dry between coats. Let final coat dry.
5. Brush one coat of rusting solution over cover. Let dry one hour.
6. Apply a second coat of rusting solution, pouring it over the first. (Small puddles, runs, and drips enhance the aged look.) Allow to dry completely.
7. Spray with two coats matte sealer. ❏

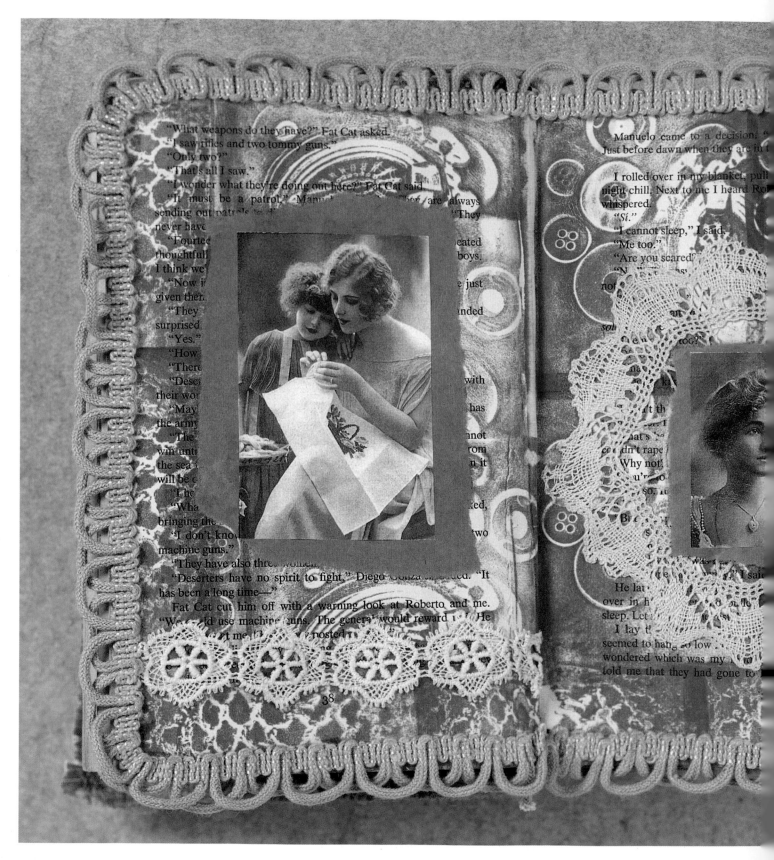

Monoprint Background

Monoprinting allows you to make a customized background quickly and easily. Using this technique, you can make your own foam stamping block by heating a piece of soft foam and creating impressions from a variety of found objects.

Foam stamping blocks can be reused many times - simply reheat to smooth the surface and press again. Try using the textures of hardware pieces, game pieces, or baskets for making foam block stamps. Be sure to work in a well-ventilated area.

SUPPLIES

2 soft, dense foam blocks, 3" x 4"

Piece of heavy lace *or* crocheted doily

Variety of buttons, drawer pulls, jewelry (These are used to make the printing block and will not be harmed.)

Pigment inkpad - Sienna

2 vintage photographs *or* photocopies of photos

Brown kraft paper, 7" x 5"

Ecru trim (for page edges) (*Tip:* Use coffee or tea to dye white trim.)

Gel medium

Fabric glue

TOOLS

Scissors

Heat gun

Brush

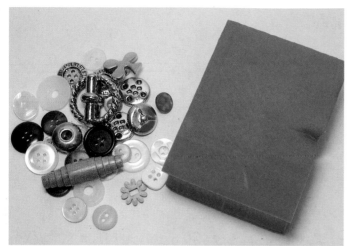

Photo 1 - Arrangement of buttons and jewelry next to foam block.

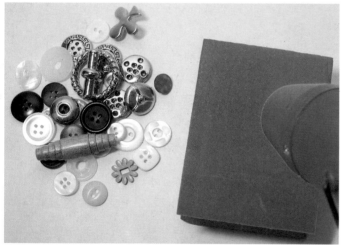

Photo 2 - Heating the foam block with a heat gun.

Monoprint Background

continued from page 77

INSTRUCTIONS

1. Prepare to make printing blocks by arranging buttons, jewelry, and draw pulls in an area roughly the same size as the foam block. (photo 1) Place lace or doily close by.
2. Heat surface of foam with a heat gun for a few seconds to soften the foam, (photo 2) then immediately press foam firmly on the arranged buttons and jewelry. (photo 3) The impressions can be seen in the foam. (photo 4)
3. Repeat process with other foam block, pressing it on the lace or doily. *Tip:* If you are unhappy with your impressions, reheat the foam to smooth it, then press again.
4. Dab pigment ink over the button/jewelry block and press on pages, applying more ink for each stamping. (photo 5)
5. Fill in or edge pages, using the lace/doily block. Allow ink to dry or heat set with heat gun.
6. Tear pieces of brown paper slightly larger than the photographs. Brush gel medium over the backs of the paper pieces and photos. Attach brown paper to pages, then photographs to brown paper.
7. Use fabric glue to attach trim around page edges. ❏

Photo 3 - Pressing the heated side of the block on the arrangement of objects.

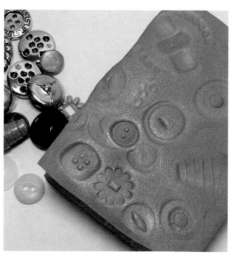

Photo 4 - The impressed block.

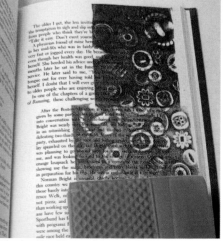

Photo 5 - Stamping a page.

Multiple Shallow Niches

You can insert tiny treasures and add an aged appearance to your book with these easy techniques.

SUPPLIES

Small embellishments - Mini bottles, dominos, charms, glass baubbles, typewriter keys

3 canceled postage stamps

2 vintage photographs *or* photocopies of photos, 1-1/2" x 2-1/2"

Vertical strip from old catalog or book, 2" x 10"

Pressed flowers, leaves, and foliage

Paper hole reinforcement

18" trim or fibers

Gel medium *or* decoupage medium

Pigment inkpad - Sienna

TOOLS

Brush

Craft knife

Cutting mat

Metal edge ruler

Hole punch

Pencil

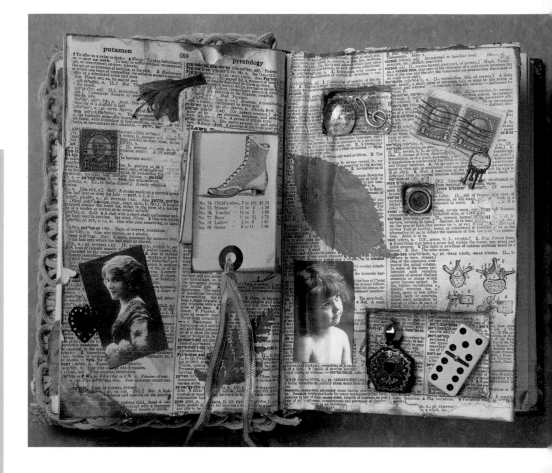

INSTRUCTIONS

1. Measure the depth of your thickest embellishments. Make a page block on the right side of the spread to accommodate them. Allow the block to dry.

2. Arrange embellishments, using project photo as a guide. Lightly trace around embellishments to plan niche sizes.

3. Place cutting mat behind page block and cut niches, using a craft knife.

4. Use gel medium to attach a page or two to the backs of the niches.

5. Tear and wrinkle page edges for an aged look. Rub the sienna inkpad along the page edges. Press a brush on the inkpad and dab ink around and in the niches.

6. Fan-fold the catalog or book strip vertically, folding to accommodate the text or drawings. Punch a hole at center bottom of last fold.

7. Dab sienna ink on paper reinforcement. Press reinforcement around punched hole.

8. Fold trim or fibers in half lengthwise. Place fold through punched hole in folded strip, then bring ends through folded loop to attach.

9. Glue embellishments and fan-folded piece to pages, using gel medium brushed on the backs.

10. Arrange stamps, photographs, charms, and pressed flowers and foliage on pages. Attach with gel medium.

11. Brush a thin coat of gel medium over the tops of the photographs and pressed flowers and foliage. ❏

Nature's Miracles

USING A BOOK WITH A SHAPED COVER AND INTERIOR PAGES CAN PROVIDE
AN INTERESTING BASIS FOR COLLAGE DESIGN. A CHILDREN'S BOOK WITH
HEAVY BOARD COVERS AND PAGES CUT IN AN UNUSUAL SHAPE WAS THE BASE
FOR THIS ALTERED BOOK. THE BOOK HAS FOLDOUT SECTIONS AT THE TOP
OF EACH PAGE; IF YOURS DOES NOT, SIMPLY ELIMINATE THE TOP SECTION OR
REARRANGE THE DECORATIVE ELEMENTS ON THE PAGE.

Pictured below: Front and back covers

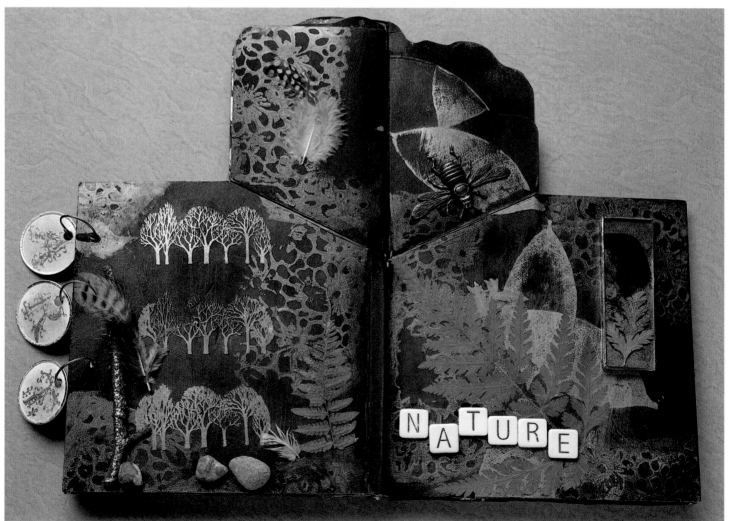

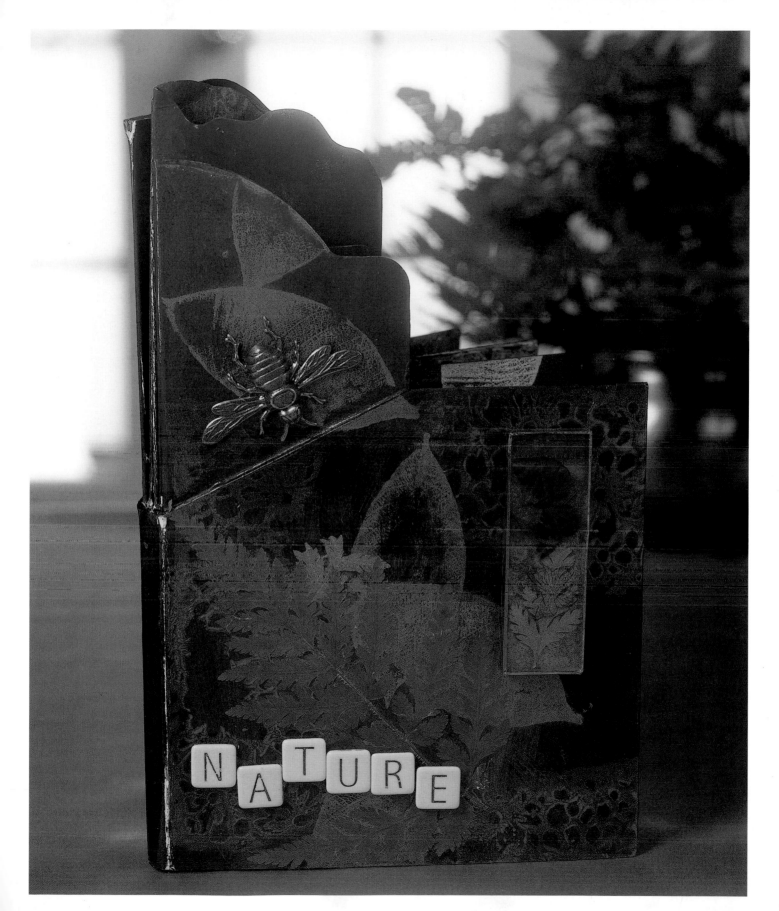

Front & Back Covers

The depth and complexity of nature are reflected here. A juxtaposition of objects - from stones to microscope slides - adds to the fascination. The base for the cover was prepared with black gesso.

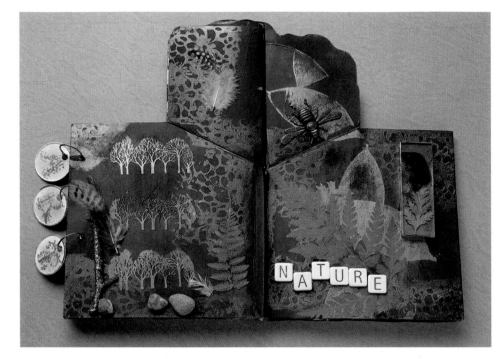

SUPPLIES

Base book - Children's board book with shaped pages

Acrylic craft paint - Gold metallic

Mica powders - Gold, green

Inkpads - Clear embossing, gold pigment

Rubber stamps - Skeleton leaf, grove of trees

Gold leaf and leaf adhesive

Decoupage medium

Brass bee charm

Microscope slides

Metal self-adhesive tape

Letter tiles ("NATURE")

Pressed fern

Small pressed leaf

3 small feathers

3 small stones

Twig, 4"

4" square piece of dense foam

Scrap of heavy lace

Industrial glue

TOOLS

Heat gun

Brush

INSTRUCTIONS

1. See the monoprint background instructions on pages 88-89 to learn how to make a foam stamp. Use the lace scrap to make the stamp.
2. Brush gold metallic paint over the prepared foam stamp and press randomly on both covers.
3. Using clear embossing ink, stamp skeleton leaves on the front cover. Dust leaves with gold and green mica powders, using a brush.
4. Stamp one grove of trees on the back cover with clear embossing ink, then dust with green mica powder.
5. Stamp two more groves of trees on the back cover, using gold pigment ink. Allow ink to dry or heat set.
6. Decoupage pressed fern on front cover.
7. Follow manufacturer's instructions to apply gold leafing to twig. Set aside to dry.
8. See Microscope Slide Embellishing in the Techniques section for instructions on preparing an embellishment using a dried leaf.
9. Arrange and glue twig, stones, and feathers to back cover, using dots of industrial glue.
10. Arrange and glue microscope slides, letter tiles, and bee charm to front cover, using industrial glue. ❏

Spring Page Spread

Layers of soft metallic colors provide a glowing contrast to the layered butterflies on this spread that celebrates spring. The pages were lightly sanded and coated with black gesso before decorating.
Instructions follow on page 84.

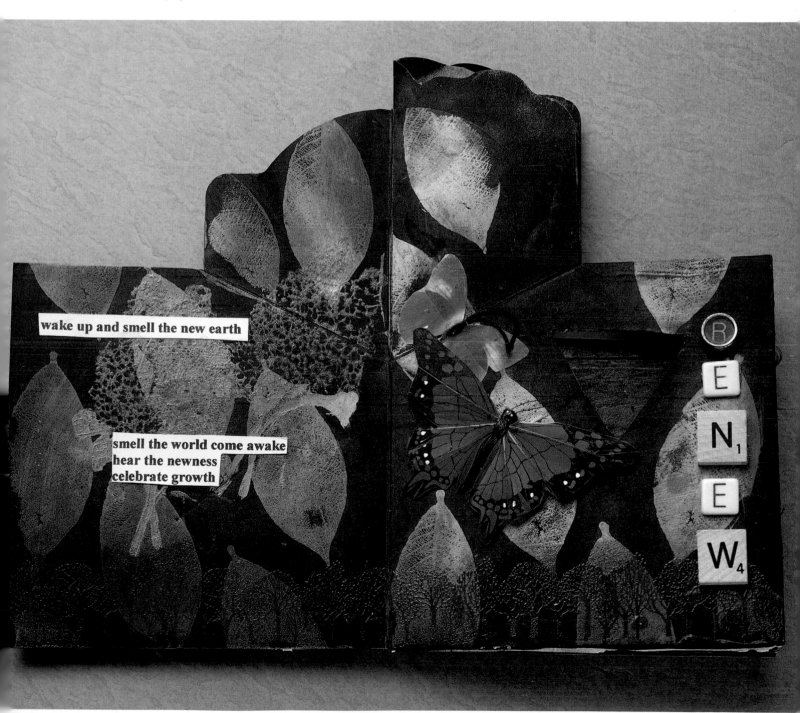

Spring Page Spread

Pictured on page 83

SUPPLIES

Acrylic craft paints - Lavender metallic, green metallic

Mica powder - green

Inkpads - Clear embossing, green pigment

Clear embossing powder

Rubber stamps - Skeleton leaf, grove of trees, hydrangea

Butterfly (cut from decoupage paper)

Feather butterfly, 4"

Letters to spell "Renew" (tiles from board games, ceramic tiles, old typewriter keys)

Computer-generated writing on ivory cardstock

Gel medium

Black thread or cording, 3"

TOOLS

Brush

Scissors

Craft knife

Metal straight edge

Cutting mat

Heat gun

INSTRUCTIONS

1. Use a craft knife, metal straight edge, and cutting mat to cut a 2" triangle on the right page.
2. Stamp skeleton leaves over both pages, using clear embossing ink. Before the ink dries, use a brush to dust green mica powder over the stamped images.
3. Stamp the grove of trees along bottom edges of both pages, using the green pigment inkpad. Emboss with clear powder.
4. Use a brush to apply metallic paints to hydrangea stamp (lavender paint on flowers and green on leaves). Press stamp on center of left page. Reapply paint to stamp and stamp close to first stamping.
5. Use scissors to trim printed cardstock close to printing. Adhere messages to left page, brushing a light coat of gel medium on the backs. Smooth papers into place.
6. Fold black thread in half, forming a V shape. Glue bottom of V to back of butterfly cutout with gel medium. Adhere butterfly to right page with gel medium.
7. Arrange letters on right page and glue to page with gel medium.
8. Glue feather butterfly to page with gel medium. ❏

Summer Nights Page Spread

Pictured right

SUPPLIES

Pearl powders - Purple, magenta, green, blue, gold, white

Adhesive inkpad (for pearl powders)

Rubber stamps - Leaf, dragonfly, grove of trees, hydrangea flower collage with butterfly, medallion, "Dream"

Face charm

Crystal dot

Computer generated printing on blue/gray cardstock

Dimensional adhesive

TOOLS

Heat gun

Scissors

Small and large soft-bristle brushes

Cloth rag

Pearlized powders and an adhesive inkpad were used to create the rubber-stamped images. The unique backgrounds change as light moves across the page.

A window from the next spread shows on one side, adding a design element to this spread too! The pages were lightly sanded and coated with black gesso before decorating.

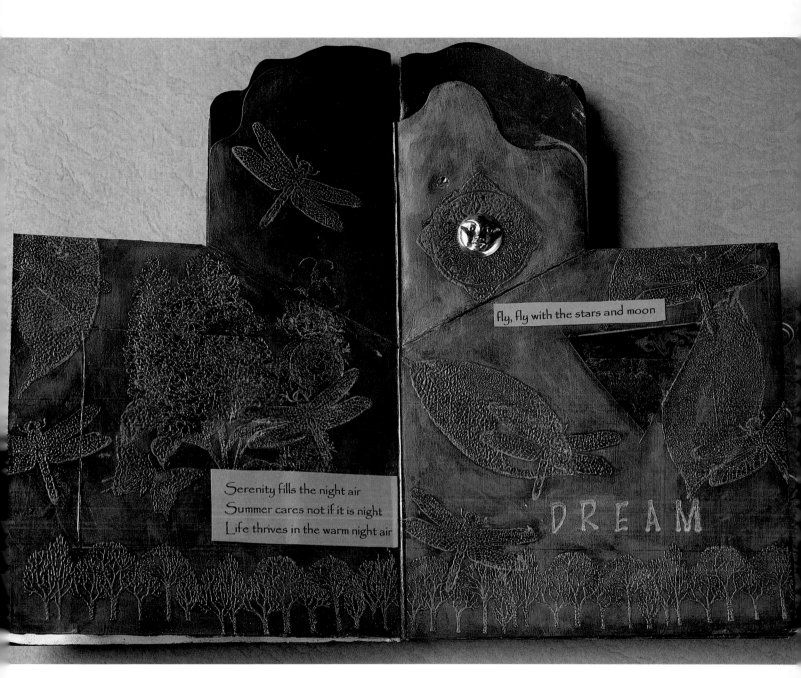

Serenity fills the night air
Summer cares not if it is night
Life thrives in the warm night air

fly, fly with the stars and moon

DREAM

INSTRUCTIONS

1. Ink stamps using adhesive inkpad. Stamp grove of trees along bottoms of both pages and leaves randomly above. Dust the stamped trees and leaves first with green powder, then add touches of the other powders. Wipe the small brush on a cloth rag between colors. Brush images lightly with the large brush to remove excess powder. Set with a heat gun.

2. Stamp hydrangea on one page and dragonflies scattered throughout. Dust hydrangea with purple and green powder. Dust dragonflies with purple, blue, and green powders. Brush lightly with the large brush and heat set.

3. Stamp the medallion in an upper corner. Dust with gold and white powder. Heat set.

4. Stamp "Dream" on right page. Dust with white powder. Heat set.

5. Trim around printing with scissors. Brush gel medium on backs and smooth onto pages.

6. Attach face charm at center of stamped medallion and crystal nearby, using dimensional adhesive.
❑

Fall Page Spread

Metallic paints form the textured background and give a rich look to these pages.
The pages were prepared by lightly sanding each page and applying a coat of black gesso.

SUPPLIES

Acrylic craft paints - Gold
 metallic, copper metallic

Gold leaf and gold leaf adhesive

Mica shard

Gold self-adhesive tape, 3/8"

Pigment inkpads - Gold, copper

Clear embossing powder

Rubber stamps - Skeleton leaf,
 maple leaf, grove of trees

Label maker with black label tape

Ginkgo leaf clip art border

Packing tape

Brass brad

Industrial glue

Sheet of bubble wrap

4" square of plastic canvas or
 screen

TOOLS

Heat gun

Brushes - Small flat, wash

Scissors

Craft knife

Metal straight edge

Cutting mat

Awl

1-1/2" round paper punch

Plastic wrap

INSTRUCTIONS

1. Use a wash brush to apply gold and copper paints randomly to bubble wrap. Press the bubble wrap on the pages here and there.

2. Brush gold paint on the canvas or screen, then press randomly on the pages. Repeat with copper paint.

3. Crumple a piece of plastic wrap in your hand and dip in gold paint. Lightly dab on the pages. Allow paints to dry.

4. Using the project photo and your mica shard as guides, cut a triangular window on the left page and a door (this one is 2-1/2" x 3-1/4") on the right page. (The triangle window should be smaller than the mica shard.) Use a craft knife, cutting mat, and metal straight edge for all cuts.

5. Punch a hole using the round punch on the upper right side.

6. Stamp grove of trees using the gold inkpad along the bottom edges of both pages. Emboss trees with clear embossing powder.

7. Randomly stamp skeleton leaf and maple leaves, using gold or copper ink. Emboss with clear powder.

8. Apply gold leaf to door according to the manufacturer's instructions.

9. Press a strip of self-adhesive gold tape along door hinge.

10. Poke a hole in door with an awl and insert brad "knob." Open ends of brad on back to secure.

11. Make two packing tape transfers using the ginkgo leaf clip art. Make one transfer almost the length of the door and the other 1-3/4" to fit in the punched window. (See the Techniques section for instructions.) When smaller transfer is dry, add tiny bits of gold leaf to the back (sticky side) and press transfer on another piece of packing tape to seal gold leaf.

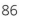

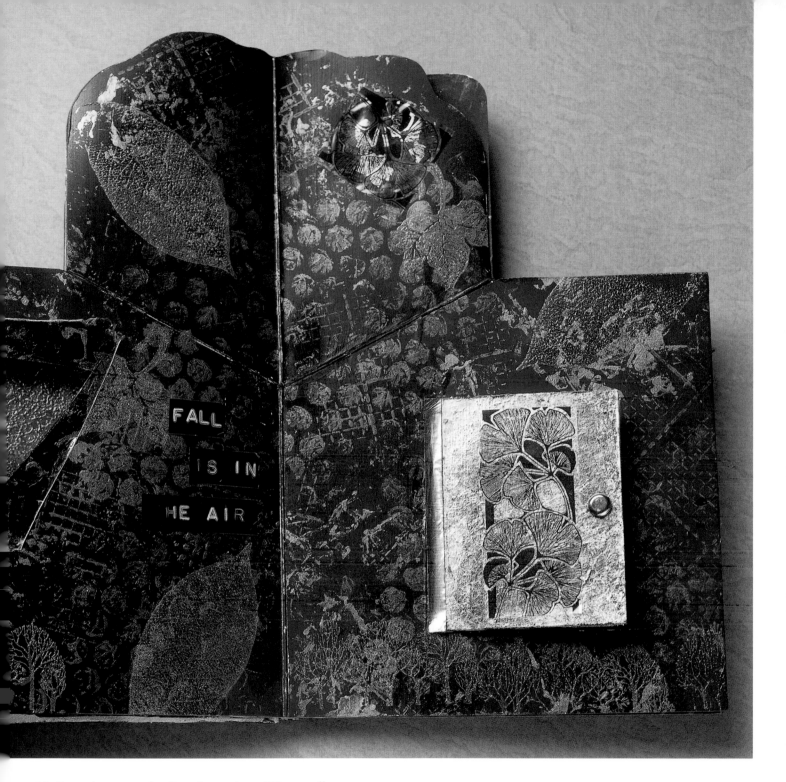

12. Press door transfer directly on door. Trim smaller
transfer just slightly larger than the punched hole.
13. Use industrial glue to glue small transfer over punched
hole and mica shard over triangle window.
14. Print words with label maker. Remove backing paper
and stick on page. ❑

Winter Page Spread

SUPPLIES

Acrylic craft paints - Pearl blue,
pearl white, silver

Rubber stamp - Grove of trees

Pearl powders - White, blue

Powder adhesive inkpad

Silver metallic paste

Silver sequin waste ribbon

4 mirrors, 1/2" square

3 white snowflake sequins

Computer-generated printing on
white vellum paper

Dimensional adhesive

TOOLS

Hot glue gun with glue sticks

Scissors

Heat gun

Brushes - Wash or glaze, small and
large with soft bristles

Sheet of bubble wrap

Paper towel or soft cloth rag

Silvers, blues, and white tones on a black background represent the snow and ice of winter. Silver sequin waste ribbon is used to impart a frozen texture to the pages, which were lightly sanded and coated with black gesso before decorating.

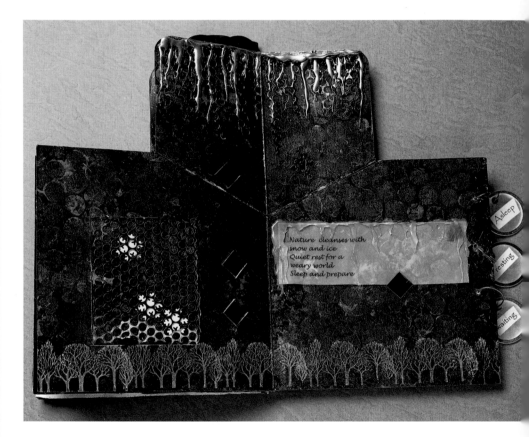

INSTRUCTIONS

1. Brush a light coat of pearl white paint across bubble wrap. Press bubble wrap, paint side down, on pages. (Don't try to evenly cover pages.) Repeat with blue and silver paints. Allow to dry completely.

2. Stamp grove of trees across bottoms of both pages, using the adhesive inkpad. Lightly dust the stamped trees with white and blue powders, applying with the small soft-bristled brush. Dust off excess powder with the large soft-bristled brush. Heat set with a heat gun.

3. Use dimensional adhesive to glue three white snowflake sequins to one page. Cut silver sequin waste ribbon to size and glue over the white snowflakes.

4. Trim computer-generated printing with scissors. Place on page, then drizzle with hot glue, pulling some of the glue down into points. Allow the glue to cool.

5. Dip a rag or a paper towel covered finger in silver metallic paste and rub the paste over the glue. Buff with a clean towel or rag.

6. Cut long shreds and thin triangles of sequin waste ribbon. Attach to tops of pages with hot glue. Add strands of hot glue across top and hanging down from top of page. Allow glue to cool. Rub with silver paste.

7. Use dimensional adhesive to adhere mirrors to pages. ❏

Ocean Page Spread

SUPPLIES

Acrylic craft paint - White

Rubber stamp - Swirl border

Pearl powders - Blue, white, aqua, gold

Adhesive inkpad

Fine grit sandpaper

Charms - Brass sun, disc, shell

Small seashells

Gold leaf and leaf adhesive

Computer generated printing

Decoupage medium

Dimensional adhesive

TOOLS

Small, disposable brush *or* cotton swab

Soft-bristled brush

Brush (for decoupage medium)

Heat gun

Scissors

Pearly white sand and gold leafed shells highlight the beach; a pearlized surf is easy to achieve with a rubber stamp and pearl powders. A window cut in a previous page adds a design element to one side of this spread.

The pages were sanded lightly and brushed with black gesso before decorating.

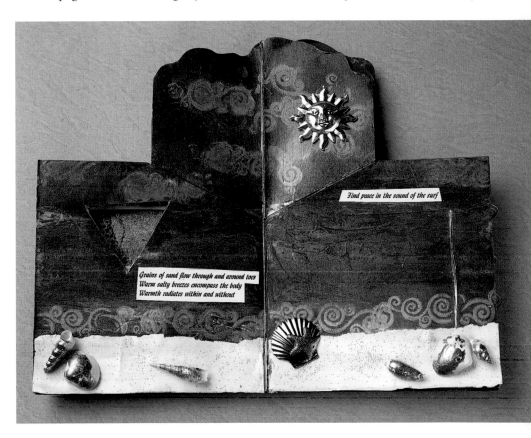

INSTRUCTIONS

1. Tear the sandpaper into strips roughly 2" wide to fit the bottoms of the pages.

2. Paint the sandpaper with white paint. Set aside to dry.

3. Dab gold leaf adhesive on shells, using a disposable brush or cotton swab. Allow to dry until clear and tacky. Press gold leaf sheets on adhesive. Brush off excess, using a soft-bristled brush.

4. Rub the adhesive inkpad across the center of the spread. Use the small-bristled brush to apply blue and aqua powders. Brush powders with the large brush to remove excess. Heat set with a heat gun.

5. Brush decoupage medium across bottoms of pages and backs of painted sandpaper pieces. Press sandpaper on pages, aligning seams.

6. Stamp overlapping swirl borders just above the sandpaper. Stamp clusters of swirls at the top of the page for clouds and four together (forming an X shape) where the sun will be. Dust the cloud and surf swirls with white powder and sun swirls with gold. Remove excess powder with large brush. Heat set.

7. Trim computer-generated printing with scissors. Brush decoupage medium across backs and smooth on pages. Topcoat printing with decoupage medium.

8. Arrange, then attach charms and shells to pages using dimensional adhesive.

9. Attach disc at center of stamped X. Add sun face charm. ❑

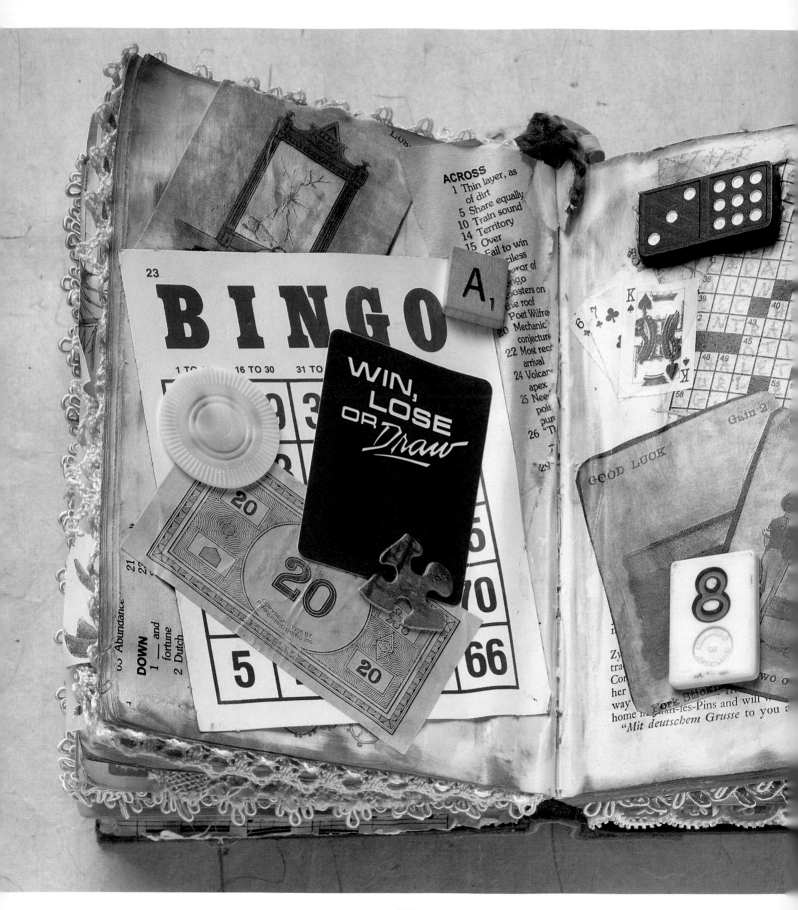

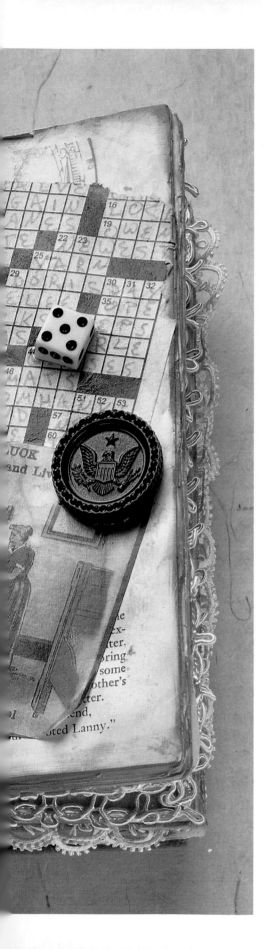

Games We Play

COLLECT BITS AND PIECES FROM GAMES PAST AND PRESENT FOR THESE PAGES. PREPARE AT LEAST A 3/8" THICK BLOCK ON ONE SIDE TO CUT NICHES FOR SOME GAME PIECES. VINTAGE CARDS AND GAME SCORE CARDS ARE AVAILABLE ON-LINE FROM MANY CLIP ART COMPANIES. THERE ARE ALSO COMPLETE BOOKS OF CLIP ART PLAYING CARDS FOR SALE.

SUPPLIES

Base book with a 3/8" thick page block on one side

Paper game pieces - Crossword puzzle, play money, game cards, vintage cards

Game pieces - Plastic and wood

Pigment inkpad - Sienna

Gel medium

Pencil

Tacky glue

TOOLS

Craft knife

Cutting mat

Metal straight edge

Brush

Scissors

Optional: Heat gun

INSTRUCTIONS

1. Rub sienna ink directly from pad on pages, concentrating the ink around the edges. Allow ink to dry or heat set with a heat gun.
2. Arrange paper pieces on pages. Adhere to pages by brushing gel medium across the backs. Allow to dry completely.
3. Arrange plastic and wood game pieces on pages. Lightly trace game pieces that are over 1/8" deep (dice and dominos, for example). Refer to the General Instructions and cut niches for the deeper game pieces. At least half the piece should sit in the niche.
4. Use tacky glue to adhere game pieces to pages and in niches. ❑

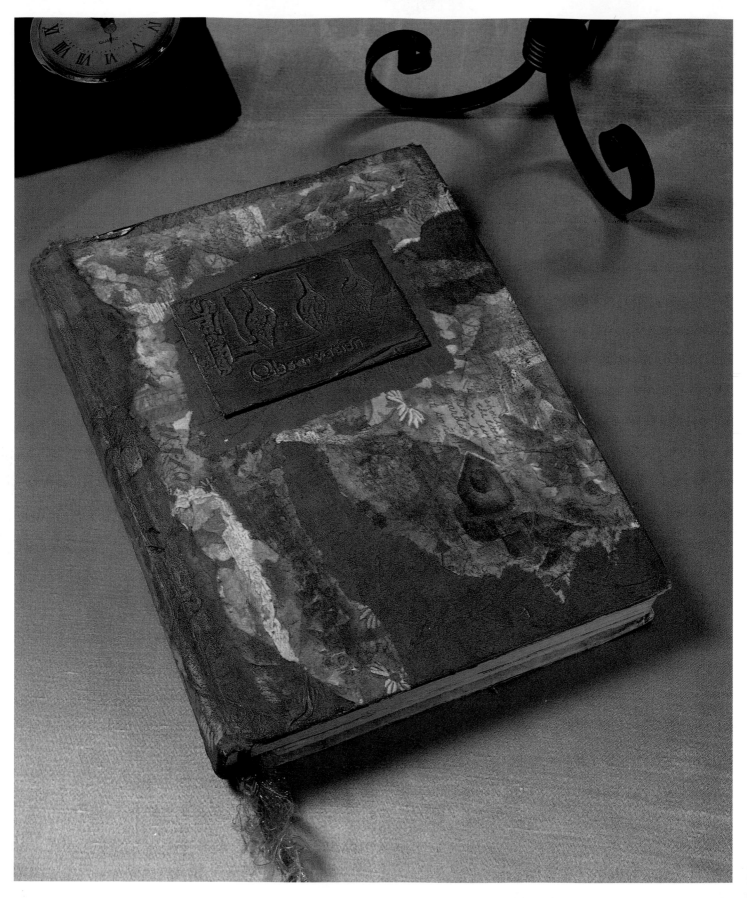

Decoupaged & Spackled Cover

OVERLAPPING LAYERS OF PRINTED PAPER NAPKIN, PLAIN TISSUE PAPER, AND HANDMADE PAPER WITH EMBEDDED LEAVES ARE DECOUPAGED ON A GESSO-PRIMED COVER. SPACKLE SPREAD ON MAT BOARD WAS RUBBER STAMPED AND PAINTED, THEN HIGHLIGHTED WITH METALLIC PASTE.

Photo 1. Spreading spackling compound on mat board.

SUPPLIES

Book - Sociology textbook, 8-1/2" x 11"

White gesso

Garden theme printed napkin

Green handmade paper, 12" x 8"

White tissue paper scraps

Metallic gold tissue paper, 6" square

Decoupage medium

Mat board, 3" x 4-1/2" (any color)

Rubber stamps - Small leaf, word

Spackling compound

Acrylic craft paints - Light olive, dark olive

Gold metallic paste

Tacky glue

TOOLS

Brush

Spackle knife or spatula

Soft rag

INSTRUCTIONS

1. Open so both front and back covers face up. Brush an even coat of gesso over covers and book spine. Allow the gesso to dry. Add another coat of gesso if original cover shows through. Set book aside to dry completely.

2. Remove the unprinted plies from the napkin. Tear the printed layer of the napkin, the white tissue paper, and the handmade paper into pieces of random sizes and shapes. Tear off the straight edges of the gold tissue paper.

Photo 2. Pressing stamps on spackling compound.

3. Arrange papers in layers on book covers and spine. Place gold paper on top half of front cover. Decoupage papers in place. Set aside to dry.

4. Spread a layer of spackling compound 1/8" across mat board, using a spackle knife or spatula. (photo 1) Quickly press rubber stamps in spackle, then remove. (photo 2) Wash stamps immediately and allow spackle to dry.

5. Paint the mat board with dark olive paint and allow to dry. Brush light olive lightly over mat board. Allow to dry.

6. Rub gold paste over mat board with your finger or a piece of paper towel, allowing some paint to show through.

7. Lightly rub gold metallic paste over the decoupaged book covers and spine and around the edges of the book cover.

8. Use tacky glue to glue mat board to front cover. ❑

Make Time for Art

THE THEMES OF TIME AND ART ARE EXPLORED IN THIS ALTERED BOOK. THE THEME - IN THE FORM OF THE TITLE - IS SPELLED OUT ON THE COVER. A FAUX POCKET WATCH IN A NICHE IS JUST ONE EXPRESSION OF THE THEME.

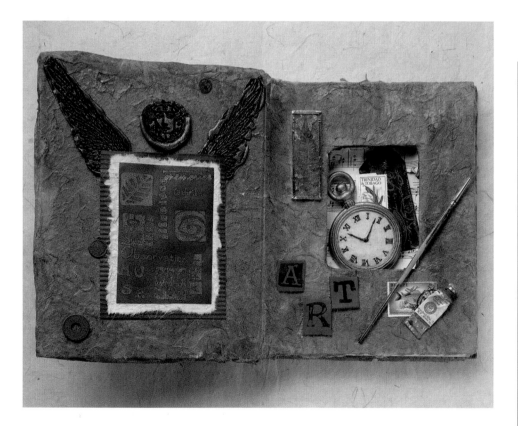

Cover

SUPPLIES

Base book, 8" x 10"

Cork sheeting, 1" wider and longer than cover measurement, including the spine

Green handmade paper, 8-1/2" x 11"

Polymer clay medallion (See the Techniques for Decorating Book Pages section for how to make one.)

Letter tiles to spell "Make Time for Art"

Fabric glue

Decoupage medium

TOOLS

Brush

Measuring tape

Straight edge

Craft knife

Niche Page Spread

This niche project was inspired by a faux pocket watch. Mulberry paper forms the background for a variety of found and made pieces. Microscope slides layered with metallic leafing and pressed fern fronds, polymer clay tiles and tags, and hot glue embossing express the theme.

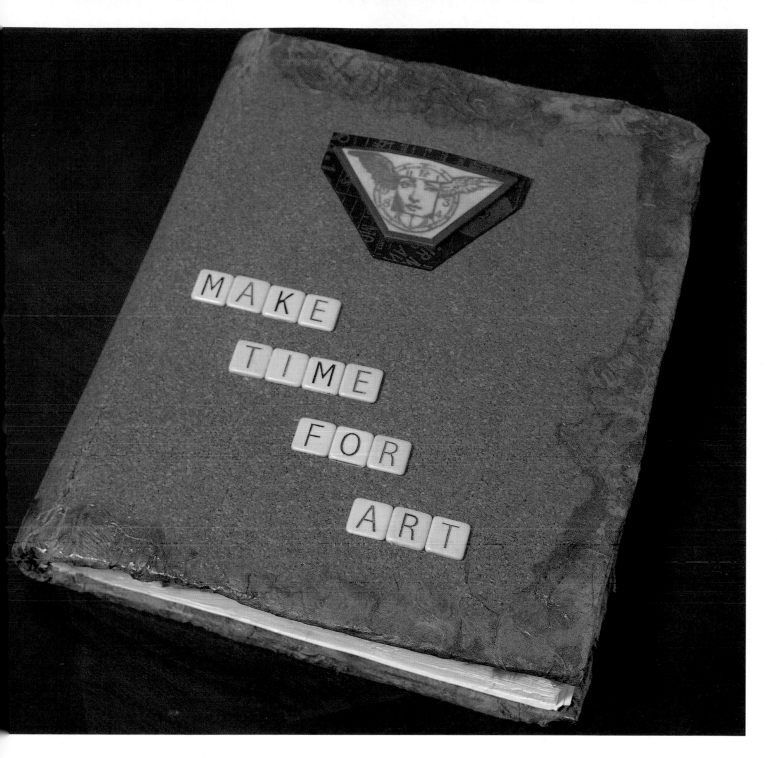

INSTRUCTIONS

1. Spread fabric glue on front cover and spine. Place cork sheeting over glue, allowing a 1/4" overhang on front edge. Smooth in place.
2. Spread glue on back cover. Wrap cork sheeting around book and onto back cover. Smooth in place. Let glue dry.
3. Trim cork flush with edges of book cover, using a craft knife.
4. Tear handmade paper into strips 1" to 2" wide. Decoupage paper strips around edges of cover. Overlap the pieces of paper and allow the edges to be uneven. Let dry.
5. Topcoat paper with decoupage medium. Let dry.
6. Glue clay medallion and letter tiles to cover. ❑

Torn Window Collage

STENCILING, A WIDE VARIETY OF PAPERS, AND PRESSED
FOLIAGE SURROUND A SMALL WINDOW ON THIS PAGE SPREAD.
IT IS PART OF THE LEATHER-BOUND MEMORABILIA BOOK;
SEE PAGE 99.

SUPPLIES

Sheet music to cover both pages

Dress pattern tissue

Handmade paper containing small
leaves

Text clipped from book and
dictionary

Stencil - Scroll border

Acrylic craft paint - Metallic sage

Decoupage medium

Gold metallic marker

Pressed fern

TOOLS

Stencil brush

Flat brush

Scissors

INSTRUCTIONS

1. Brush decoupage medium over both
 pages and backs of sheet music.
 Place sheet music on pages smooth-
 ing papers from the center outward.
 Brush a coat of decoupage medium
 across tops of papers. Allow to dry.
2. Place stencil across both pages. Pour
 a small amount of paint on a palette
 or paper scrap. Dip a stencil brush
 in paint, then dab brush on scrap
 paper to remove excess. Apply paint
 through stencil cutouts, using an up
 and down motion while you hold
 the stencil firmly to the surface.
 (Photos illustrate the stenciling
 technique.) Lift stencil straight up
 to remove. Allow paint to dry.
3. Tear and cut pattern tissue,
 handmade paper, and text. Arrange
 and layer papers, then apply to
 pages using decoupage medium.

Ready to stencil.

*Applying paint through the stencil
openings to page. Hold the brush
perpendicular to the page.*

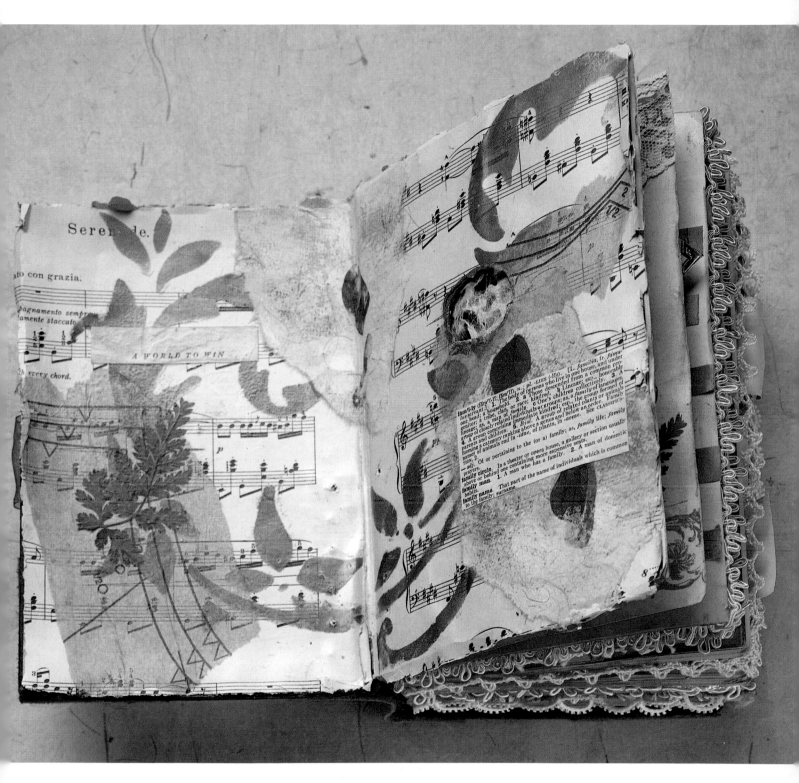

4. Decoupage fern to a page. Coat both pages with decoupage medium. Allow to dry.

5. Cut a rough 1" round hole on right page, using a craft knife. (Hole should look chiseled.) Color edges of hole with gold marker. (Design on next page block will show through window.) ❑

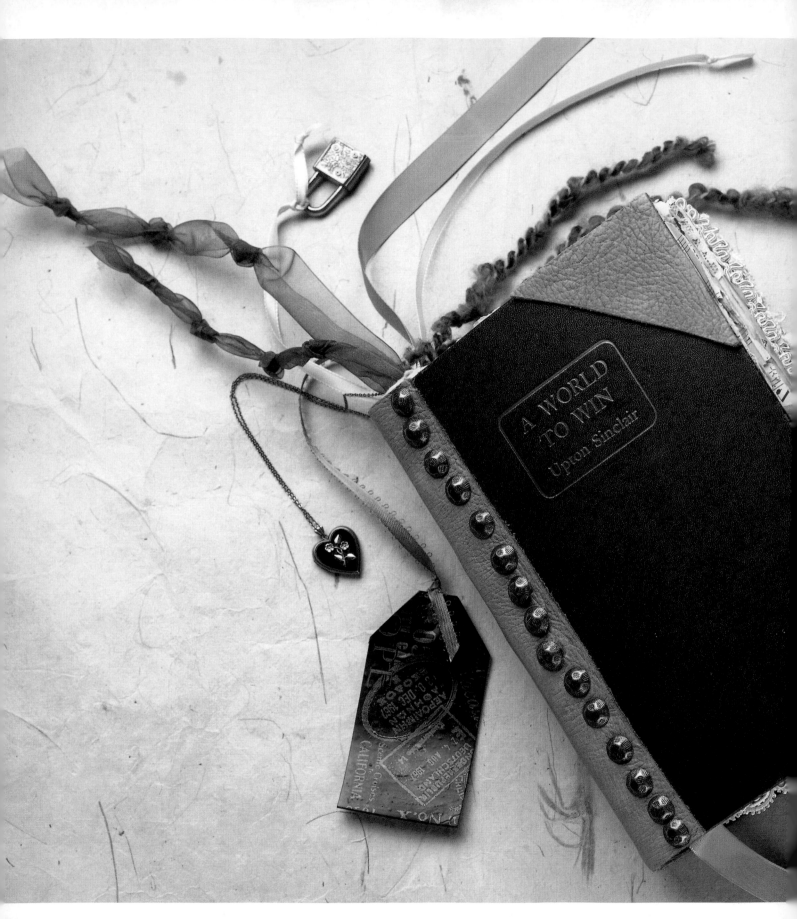

Leather-bound Memorabilia Book

THIS BASE BOOK'S COVER WAS TRIMMED WITH LEATHER AND UPHOLSTERY TACKS; THE PAGES INSIDE INCLUDE EDGE TRIMS, INTERESTING FOLDS, WEAVING TECHNIQUES, POCKETS, AND RIBBON AND CHARM TRIMS.

FOLDING AND WEAVING PAGES ADDS DIMENSION TO YOUR BOOK AND PROVIDES INTERESTING PLACES TO INSERT PHOTOS, EPHEMERA, AND EMBELLISHMENTS. THE BACK OF THE WOVEN PAGE IS ALSO TEXTURED, GIVING YOU TWO BACKGROUNDS FOR YOUR TIME.

LAYERED POCKETS ARE THE PERFECT PLACE TO STORE SECRET MESSAGES, PHOTOS, AND ALL SORTS OF PAPER EPHEMERA.

Cover

SUPPLIES

Base book, 5-1/2" x 8"

Supple leather - two 2-1/2" squares, one piece 8" long and 2" wider than spine

30-40 upholstery tacks

Fabric glue

TOOLS

Ruler

Scissors *or* rotary cutter

Cutting mat

Wire cutters

Hammer

INSTRUCTIONS

1. Cut leather to fit spine. Cut leather squares in half diagonally.
2. Glue leather to book cover.
3. Trim 1/8" from each tack, using wire cutters. Hammer tacks along length of spine. ❏

Woven & Folded Pages

SUPPLIES FOR WOVEN PAGE

Reserved text page

Rubber stamps - Background, word, watch

Chalk inkpad - Sage

Pigment inkpads - Sienna, black

Small white feather

TOOLS

Cutting mat

Metal ruler

Craft knife

Glue stick

Optional: Heat gun

(No supplies are needed for folded pages)

INSTRUCTIONS FOR WOVEN PAGE

1. Make a block of pages. Place cutting mat behind block. Use the metal ruler and craft knife to cut vertical slits 3/4" apart in block, leaving at least 3/4" of uncut page on all sides.
2. Rub sage inkpad on reserved text page, covering the page. Dab sienna ink directly from the inkpad in four or five places on top of sage ink. Rub inks with your finger to blend. Allow inks to dry or heat set with heat gun.
3. Ink background stamp with black ink and press on colored text page. Allow inks to dry or heat set with heat gun.
4. Place colored and stamped text page on cutting mat. Cut in strips 1/2" wide, using metal ruler and craft knife. Lay strips to one side, keeping them in their original order.
5. Pick up top strip and weave over and under through slits in page. (photo 1) Weave next strip, staggering the placement. Continue weaving (photo 2) until page is full and strips are tight to each other. Glue ends of woven strips to front and back of page block, trimming as needed.
6. Stamp word and watch on page using sienna ink.
7. Insert feather through weaving. ❑

INSTRUCTIONS FOR FOLDED PAGES

1. Fold down top corner of each page to spine. (photo 3)
2. Fold up bottom corner of each page to spine. (photo 4)
3. Insert ephemera or photos into pockets formed from folds. ❑

Photo 1. Weaving the first strip of paper.

Photo 2. Continuing to weave strips of paper.

Photo 3 - Folding down the top corner.

Photo 4 - Folding up the bottom corner.

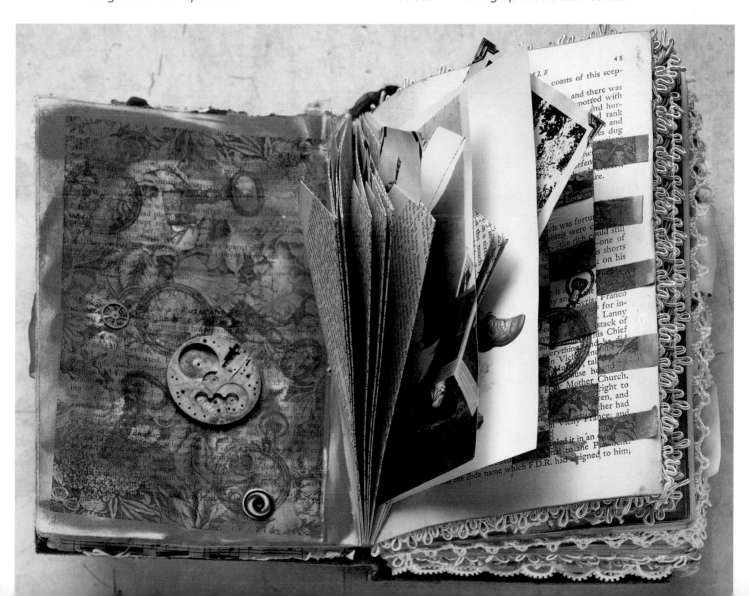

Layered Pockets

SUPPLIES

Pigment inks - Amber, sienna, soft gray, burgundy

Rubber stamps - Ornamental numbers

Paste *or* glue stick

INSTRUCTIONS

1. You'll need 11-20 book pages to construct these pockets, glued this way: Glue the back five pages together. Divide the remaining pages into three groups. Allow glue to set.
2. Tear the edges of the pages closest to the back five-page group in a jagged manner, starting about an inch in from the edge. Tear the next set of pages the same way, making sure the edges of the first group shows. Repeat for the third group of pages.
3. Rub the gray and burgundy inkpads on the papers, applying more ink on the edges.
4. Dab amber and burgundy inks randomly on the pages.
5. Stamp dates using ornamental numbers with sienna ink.
6. Glue top and bottom 1" of all pages together, sealing top and bottom edges to make pockets. ❏

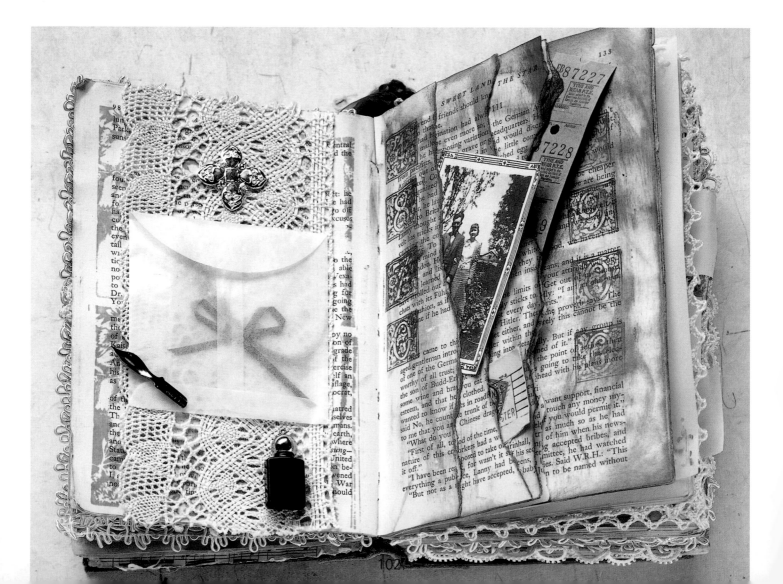

Cheesecloth Masking

Instructions begin on page 104

COVERING A BOOK COVER OR PAGE SPREAD WITH CHEESECLOTH GIVES AN ETHEREAL QUALITY. USE NUMEROUS LAYERS OF CHEESECLOTH TO DISGUISE FLAWS OR ACHIEVE A CLOUD-LIKE EFFECT. A WASH OF COLOR CAN BE ADDED FOR A VINTAGE LOOK; TRY A BLUISH WASH FOR THE LOOK OF WATER. THE EXAMPLE PICTURED BELOW IS A BOOK COVER.

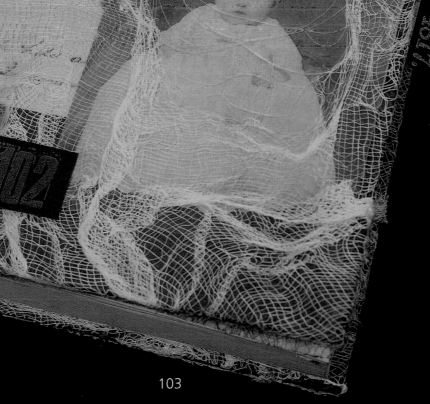

Pictured on page 103

SUPPLIES

Book to cover, 6" x 9-1/2"

Vintage paper ephemera (old letters, sheet music, documents) *or* color photocopies of ephemera

Vintage photographs *or* photocopies of photos

Text from old book

Black cardstock

Rubber stamps - Numbers

Pigment inkpad - Copper

Cheesecloth

Gel medium

Double stick tape

TOOLS

Scissors

Brush

INSTRUCTIONS

1. Place the book flat on your work surface. Arrange the papers and photographs as desired. Trim papers with scissors or tear edges.

2. Brush gel medium over book cover. Place papers, one layer at a time. Brush another coat of gel medium over the top of each paper as you go.

3. Cut a piece of cheesecloth 5" larger on all sides than the book cover. Poke holes in the cheesecloth with your fingers in the approximate areas where details from your adhered papers will show through.

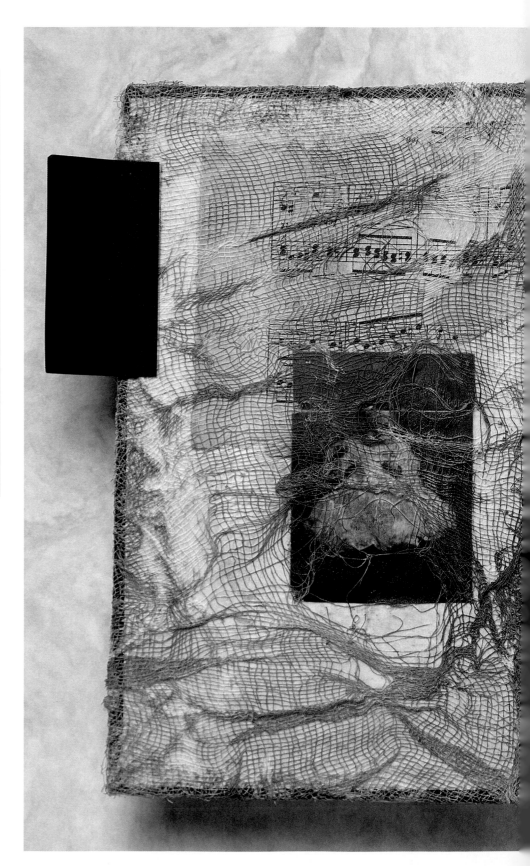

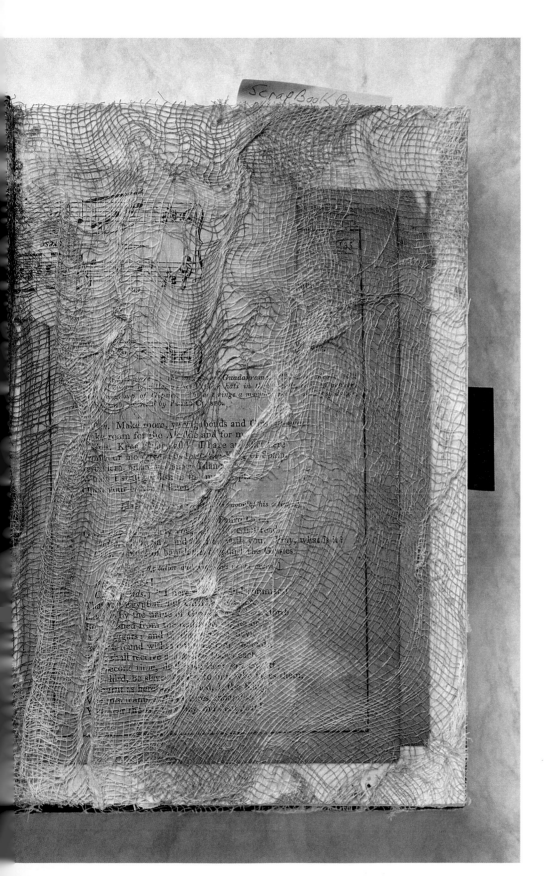

4. Brush a generous coat of gel medium over entire surface. Press the cheesecloth on the cover around the holes you poked. Allow the cloth to wrinkle and have some folds but no large bumps. Allow 1" to hang over the edges.

5. Brush another generous coat of gel medium over the cheese-cloth and set aside to dry.

6. Turn over the book, exposing the inside covers. Trim the excess cheesecloth around the edges with scissors or fold over the edges of the cloth and adhere to inside covers with gel medium.

7. Stamp three sets of numbers on cardstock in different sizes, leaving 1" below the stamping blank. Trim around each set of stamped numbers, leaving 1/2" of blank cardstock at the bottom on two sets and trimming the last set close to the numbers. Apply double-stick tape to the bottom fronts on the two sets with blank cardstock at the bottom. Stick the tape, adhering one number along the side of the cover and another on the first block of pages like tabs.

8. Apply double-stick tape to back of last set of stamped numbers. Stick to the front cover. ❑

Pictured at left: Cheesecloth masking also can be used effectively on page spreads, using the same technique. If you like, you can tint the cheesecloth with coffee or tea or diluted paint. If you do, let it dry before you apply it to the book.

Tags & Envelopes

TAGS, ENVELOPES, AND POCKETS ARE OTHER WAYS TO INCLUDE, STORE, AND LABEL PHOTOS OR EPHEMERA IN COLLAGES. YOU CAN MAKE LABELS ON A COMPUTER, USING DIFFERENT FONTS FOR VARIETY.
TAGS AND ENVELOPES CAN ALSO BE SURFACES FOR DECORATING. YOU CAN GLUE, DECOUPAGE, OR TRANSFER IMAGES TO THEM, THEN ADD THEM TO PAGES OR COVERS.

Pockets of Memories

The labeled envelopes and tags on this spread add layers of interest, inviting and allowing the viewer to discover what's inside. This page spread is part of the Leather-bound Memorabilia Book.

Instructions begin on page 108.

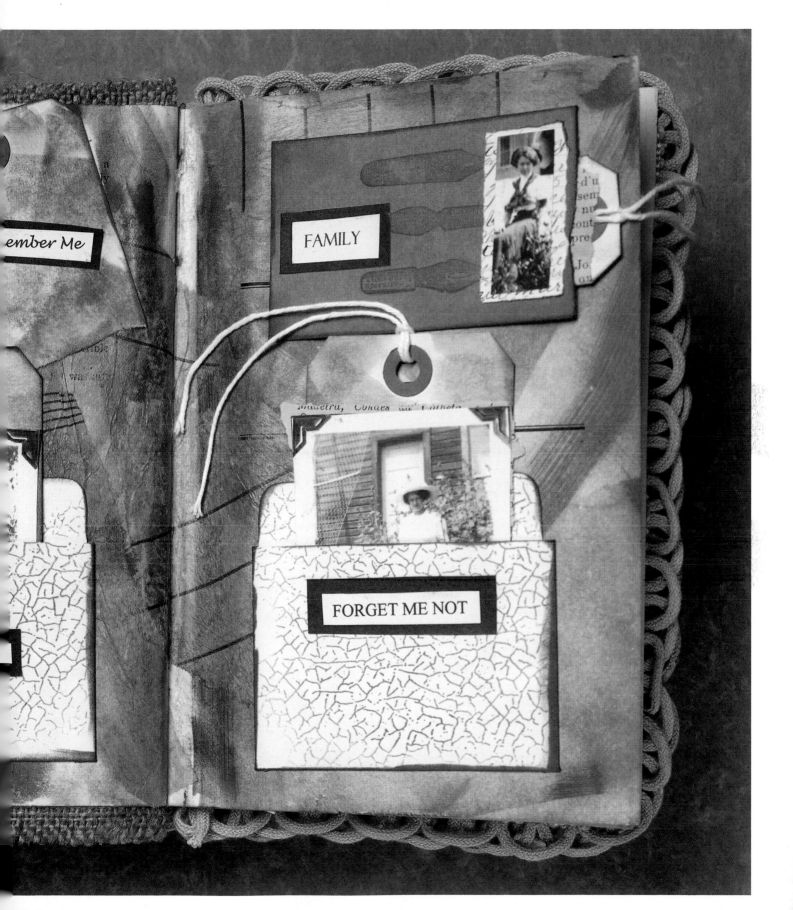

Pockets of Memories *Pictured on page 106 - 107*

SUPPLIES

2 library pockets

3 manila tags, 4-3/4" x 2-3/8"

Coin envelope

Dress pattern

Photocopies of vintage photos
 (Size them to fit tags and coin
 envelope.)

Book text and script

Black cardstock

Computer-generated printing
 (for labels)

Pigment inkpads - Ochre, sienna

Rubber stamps - Crackle
 background, pen nibs

Gel medium

TOOLS

Brush

Scissors

Optional: Heat gun

INSTRUCTIONS

1. Rub both pages randomly with both inkpads, putting more ink on the edges and in some spots.
2. Rub sienna inkpad on all tags and around the library pockets and coin envelope edges. Allow inks to dry or heat set with a heat gun.
3. Tear pattern paper into random shapes. Brush gel medium over both book pages, then press pattern paper in wet medium. When medium has set, use scissors to trim pattern paper around page edges.
4. Stamp both library pockets, using the crackle stamp with sienna ink. Stamp pen nibs on the coin envelope. Allow inks to dry or heat set.
5. Trim computer-generated printing with scissors to make labels. Cut mats from cardstock slightly larger than printing. Brush gel medium on backs of printing. Center printing on cardstock and press in place.
6. Tear bottom third off one tag. Adhere photos or text to remaining tags and one side of coin envelope, using gel medium.
7. Adhere labels to tags, pockets, and coin envelope with gel medium.
8. Arrange pockets, coin envelope, and torn tag. Adhere to pages by brushing a generous coat of gel medium across the backs. Press down firmly.
9. Insert remaining tags in pockets. ❑

Vintage Tagged Photos *Pictured on opposite page*

INSTRUCTIONS

1. Dye doily and fabric buttons in strong coffee or tea until they are two shades darker than desired shade. Remove. Hang doily to dry.
2. Stamp images randomly across both pages, using the two rubber stamps with terra cotta and sage chalk inks.
3. Rub sienna inkpad along all page edges. Set pages aside to dry.
4. Trim one photocopy with scissors to approximately 3" x 5".
5. Trim remaining photocopies to 1" larger on all sides than tags. Heat the woodburning tool according to manufacturer's instructions. Place photocopy, toner side down, on tags. Slowly and carefully run the woodburning tool over the surface. Lift one corner to check on transfer progress. If transfer is not complete, replace copy and run tool over surface again. Transfer photos to all tags.
6. Arrange collage. Use the glue stick to attach the trimmed photocopy and all tags to pages. See the project photo for placement ideas.
7. Use fabric glue to attach the doily.
8. Randomly glue buttons and faux pearls, using fabric glue. ❑

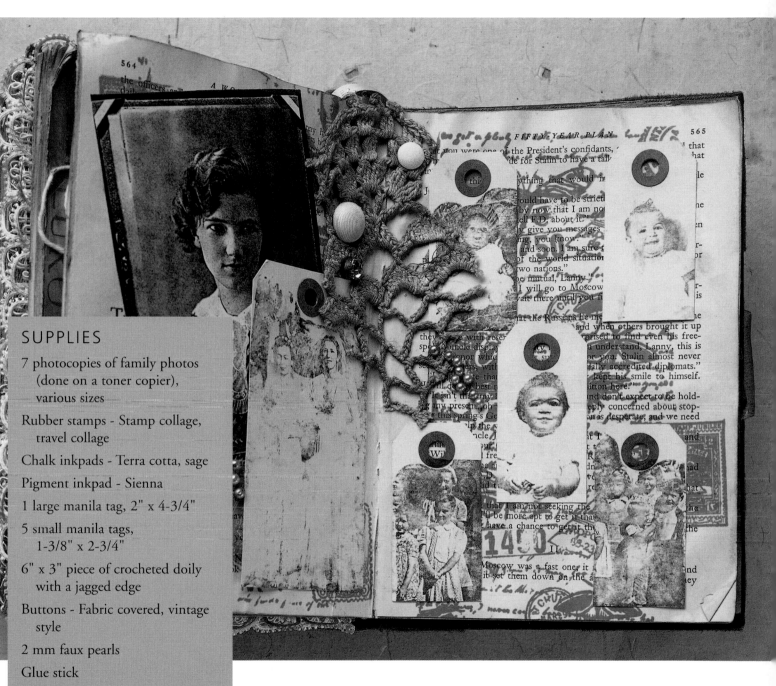

SUPPLIES

7 photocopies of family photos
(done on a toner copier),
various sizes

Rubber stamps - Stamp collage,
travel collage

Chalk inkpads - Terra cotta, sage

Pigment inkpad - Sienna

1 large manila tag, 2" x 4-3/4"

5 small manila tags,
1-3/8" x 2-3/4"

6" x 3" piece of crocheted doily
with a jagged edge

Buttons - Fabric covered, vintage
style

2 mm faux pearls

Glue stick

Fabric glue

Strong coffee or tea, cold

TOOLS

Woodburning tool with wide
round tip

Scissors

These pages show two ways of using photocopies of family photos. Aging techniques, old lace, and fabric-covered buttons enhance the vintage look. This page spread is part of the Leather-bound Memorabilia Book. Instructions begin on previous page.

Bleached Stamped Pages

BLEACH STAMPING IS AN EASY WAY TO MAKE A COMPLEX-LOOKING BACKGROUND FOR YOUR PAGES. CHOOSE INK COLORS THAT PICK UP COLORS IN YOUR PHOTOS OR TRANSPARENCIES FOR A COHESIVE LOOK. BE SURE TO TEST INKS ON SCRAP PAPER FIRST - THE BLEACHING PROCESS CAN PRODUCE UNEXPECTED COLOR CHANGES.

SUPPLIES

Pigment inks (here, gold, amber, burgundy, sienna, dark green, light green)

Foam stamp - Flower with leaves

3 colorized photocopies, of photos, 1-1/2" x 2-1/2"

Color transparency, 3" x 5"

Piece of sheet music, 4" x 6"

8 silver photo corners

Piece of broken jewelry

2 gold-tone eyelets

Glue stick

Dimensional adhesive

Bleach

Paper towels

TOOLS

Eyelet setting tool

Disposable plate or palette

INSTRUCTIONS

1. Working one color at a time, spread ink horizontally across both pages. Overlap and blend inks, using the pads or your finger, so there is not a hard line between the colors.
2. Fold a paper towel to fit on a disposable plate. Pour bleach on paper towel to saturate. (photo 1) Press flower stamp on the bleach-saturated paper towel (photo 2), then press randomly on the page and lift straight up. Reload stamp with bleach and stamp again.

Photo 1. Saturating paper towel with bleach.

Photo 2. Loading a stamp with bleach by pressing on the bleach-saturated paper towel.

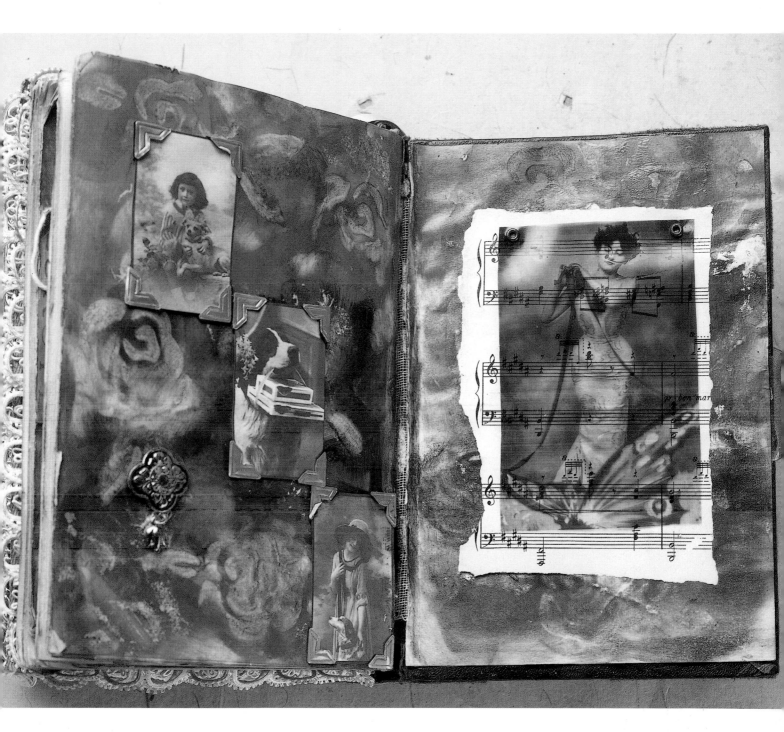

Repeat as desired. Allow pages to dry completely.

3. Arrange and attach photocopied photos, using photo corners and a glue stick.

4. Use dimensional adhesive to attach jewelry to page.

5. Tear sheet music so it is slightly larger than the transparency. Glue sheet music to page with the glue stick.

6. Place transparency over sheet music and attach to page with eyelets. ❏

Vintage Script Page Spread

COLLECTING PAPER EPHEMERA IS FASCINATING; USING IT IN YOUR CREATIONS IS EVEN BETTER. (IF YOU DON'T WANT TO USE THE ACTUAL ITEMS, MAKE GOOD QUALITY PHOTOCOPIES.) THIS SIMPLE, EFFECTIVE PAGE SPREAD IS THE RESULT OF LAYERING SEVERAL PIECES OF EPHEMERA - THE TEXT FROM THE BASE BOOK, TEXT FROM ANOTHER BOOK, A PAGE FROM AN OLD LEDGER, AND A PHOTOGRAPH.

SUPPLIES

Foreign language text page

Handwriting from an old ledger

Vintage photograph

Gel medium

TOOLS

Scissors *or* paper trimmer

Brush

INSTRUCTIONS

1. Brush gel medium across the back of the text page. Place text, gel side down, across both pages, centering it. Smooth down.
2. Trim handwritten ledger page to fit diagonally across the text, using scissors or a paper trimmer. Adhere.
3. Trim photograph and adhere to page. ❑

baked earth of the courtyard. Holding the
...in his hand, he strolled toward the eleven...

You

eyes

the
ope
fell
wly
to

my
om

of
id.
rn
wly
he
ne
ds

nd
he
ok
ir

Rebecca Throne
by her betrothed
Frank Studman

William E. Throne

Rec'd June
Ways atty.
full of a

capitulo,
...ra, crêmos que co-
...erencias a Fructuoso, das
...as pag. preliminares d'este en-
...a Biblioteca Publica d'esta cidade, na
...do Canto.
...cap. 4 de Liv. III, e em outro art....

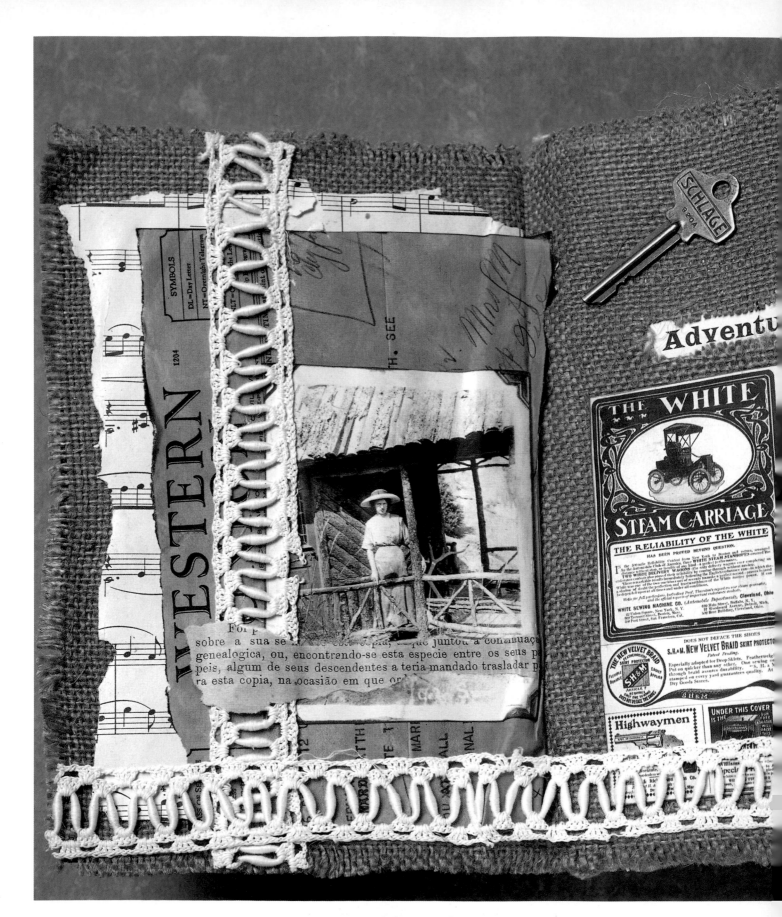

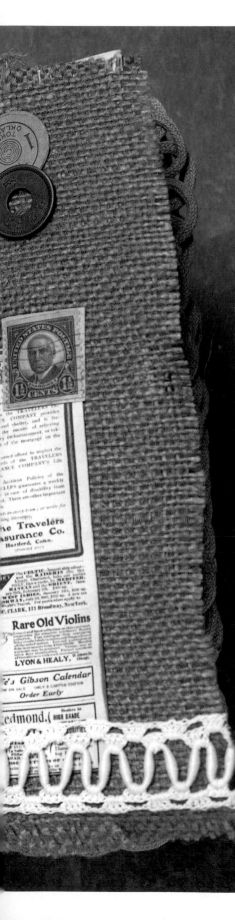

Fabric Page Spreads

FABRIC CAN BE USED TO MASK BOOK TEXT AND CREATE A UNIQUE BACKGROUND FOR A COLLAGE. YOU CAN CUT HOLES IN THE FABRIC TO CREATE WINDOWS THAT SHOW PORTIONS OF TEXT FROM THE BASE BOOK, IF YOU LIKE.

SUPPLIES

Burlap, size of page spread plus 2" (Example: If spread is 8" x 10", piece should be 10" x 12".)

Ivory lace or trim, one piece the width of the spread, another the height of the spread

Paper ephemera (ads, sheet music, telegraph message, stamp, book text, photograph)

Key

Tokens

Gel medium

Fabric glue

Adhesive for metal or glass

TOOLS

Brush

Scissors

Ruler *or* measuring tape

White chalk

INSTRUCTIONS

1. Choose some text that you want to reveal from the page of the base book. To make a window for the text, rub it heavily with white chalk. Position the burlap on the page spread and rub hard over chalked area to transfer the outline. Cut away chalked area with scissors. Brush any remaining chalk from page.

2. Generously brush gel medium over pages. Position burlap on pages and smooth in place. Allow gel medium to set.

3. Pull around from edges of burlap to create a fringed border.

4. Layer and arrange paper ephemera on pages, using photo as a guide. Adhere all but a small piece of book text to pages with gel medium.

5. Arrange fabric trim on pages as shown and adhere with fabric glue.

6. Brush gel medium across back of remaining piece of book text and adhere to page, overlapping trim.

7. Use metal adhesive to attach key and tokens to pages. ❏

Needlework Page Spread

THIS SPREAD IS IDEAL FOR DISPLAYING FRAGILE OR TIMEWORN PIECES OF NEEDLEWORK - YOU CAN OFTEN FIND BEAUTIFUL PIECES AT THRIFT STORES. CREATE A THEME BY STITCHING A MESSAGE ON A DOILY WITH A PLAIN CENTER OR USE A PIECE THAT'S ALREADY EMBROIDERED.

WHO WOULD THINK A SIMPLE BROWN PAPER BAG COULD MAKE SUCH AN INTERESTING BACKGROUND? TRY THIS TECHNIQUE WITH OTHER INK COLORS.

SUPPLIES

Doily *or* needlework to fit page spread

Large brown paper bag

Pigment inkpad - Brown

Assorted buttons

Gel medium

Fabric glue

Optional: Black embroidery floss

TOOLS

Brush

Optional: Embroidery needle, disappearing ink marker, scissors, heat gun

INSTRUCTIONS FOR OPTIONAL EMBROIDERY

1. Plan your message on paper. Dividing the words in half to center and keep the message short and simple.
2. Print the message on the doily, using a disappearing marker.
3. Embroider message with black floss. Secure ends of floss at back.

INSTRUCTIONS FOR COLLAGE

1. Tear a piece from the paper bag about the same size as page spread. Crumple in your hand. Smooth out, then crumple again. Smooth out once more.
2. Hold the inkpad parallel to the bag and brush the bag's surface with the inkpad. Allow ink to dry or heat set with a heat gun.
3. Adhere the paper to the page spread with gel medium.
4. Dab fabric glue on the back of the needlework and smooth on the page spread.
5. Arrange, then glue buttons in place, using fabric glue. ❏

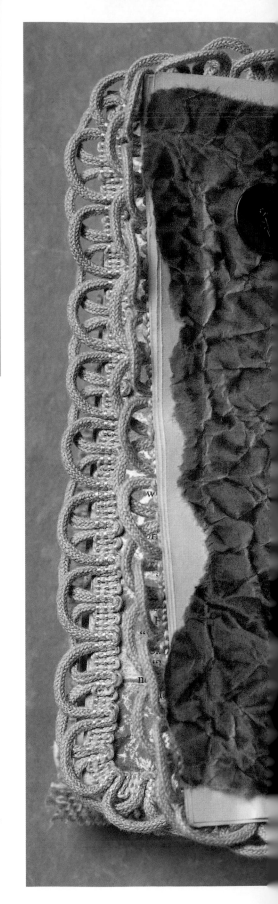

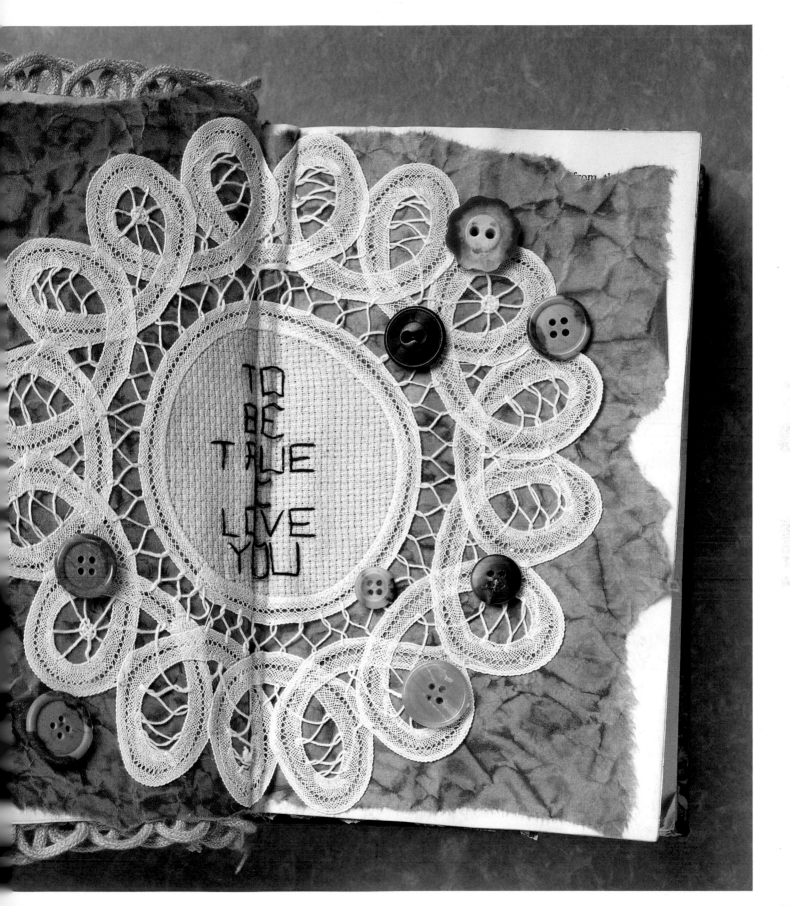

Bon Voyage

THIS BOOK WAS DESIGNED AS A GIFT FOR A FRIEND WHO TRAVELS A GREAT DEAL FOR HER WORK BUT NOT YET TO THE PLACES IN EUROPE SHE WANTS TO GO. I LEFT LOTS OF SPACE ON THE PAGES SO SHE COULD ADD HER OWN NOTES AND MEMORABILIA.

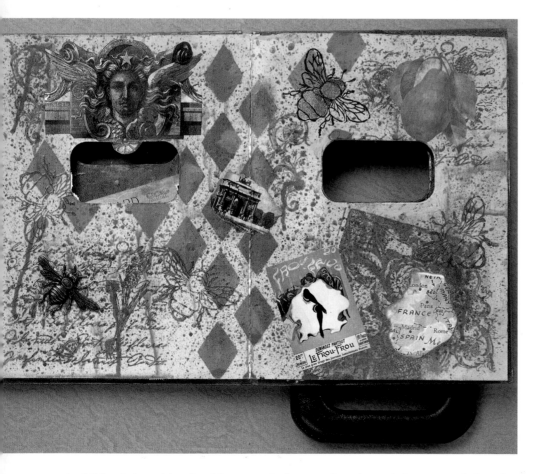

A children's board book with precut holes running through it was sanded and coated with gesso. For an "olde world" look, layers of gesso were applied with a palette knife and a stiff brush, then sanded to smooth down rough spots and larger bumps. Washes of ochre, gold, copper, and olive green paints were applied over the gesso; I allowed some washes to run down the pages.

Rubber stamped designs, handmade papers, postage stamps, and ephemera representing Britain, France, and Italy were arranged on the pages. I left blank spaces so my friend could add personal items at a later date. Three-dimensional elements were added last - a glassine envelope of stamps from around the world, and other embellishments such as a brass bee, some sheer ribbon, a rusted washer, and a layered microscope slide.

A faux passport was created for the front cover by altering then photo-copying my passport at a reduced size. (I wasn't sure that it's legally permissible to accurately copy a passport, so I did it this way.) A ceramic tag was rubber stamped with a travel collage stamp after being rubbed with a sienna-colored inkpad. The ceramic tag and foreign postage stamps were glued around and over the passport to complete the front cover.

A luggage handle was attached to the bottom back cover to form an easel to support the book for display. The handle was attached with both glue and small screws. The rest of the back cover was left blank for future travel ephemera.

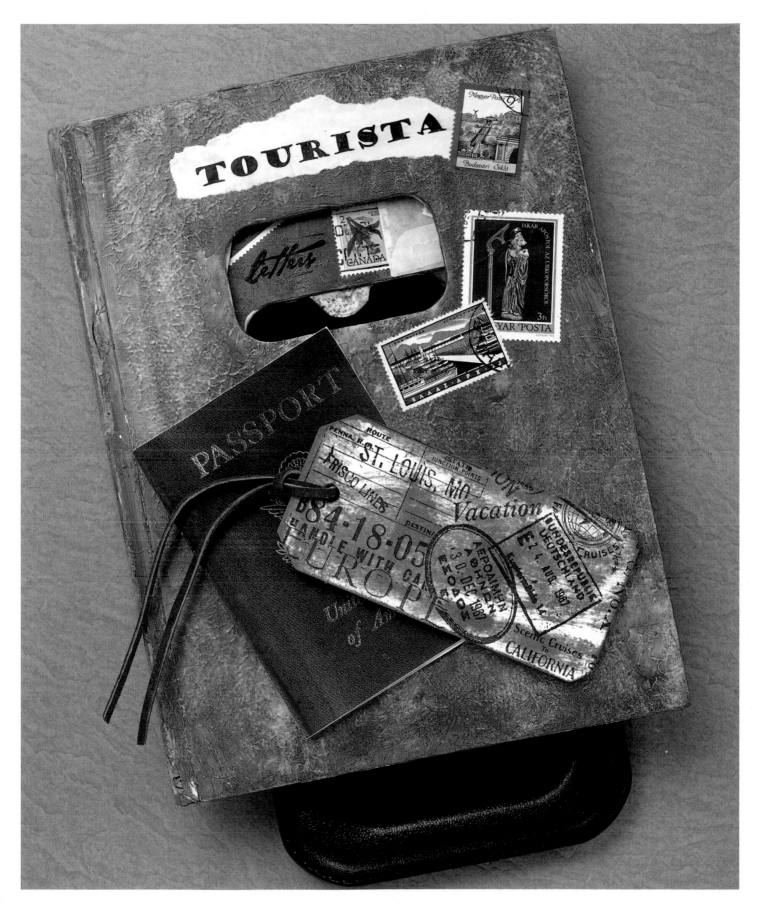

Dorothy's Travel Fashion Book

By Dorothy Egan

THE BASE BOOK FOR THIS ONE WAS A CHILD'S BOARD BOOK FROM A DOLLAR STORE. I THINK IT WAS SUPPOSED TO BE A LUNCH BOX, BUT TO ME IT LOOKED LIKE A SUITCASE SO IT INSPIRED A TRAVEL THEME - I CHOSE "TRAVELING IN STYLE" AND COMBINED TRAVEL IMAGES LIKE MAPS AND POSTERS WITH FASHION IMAGES.

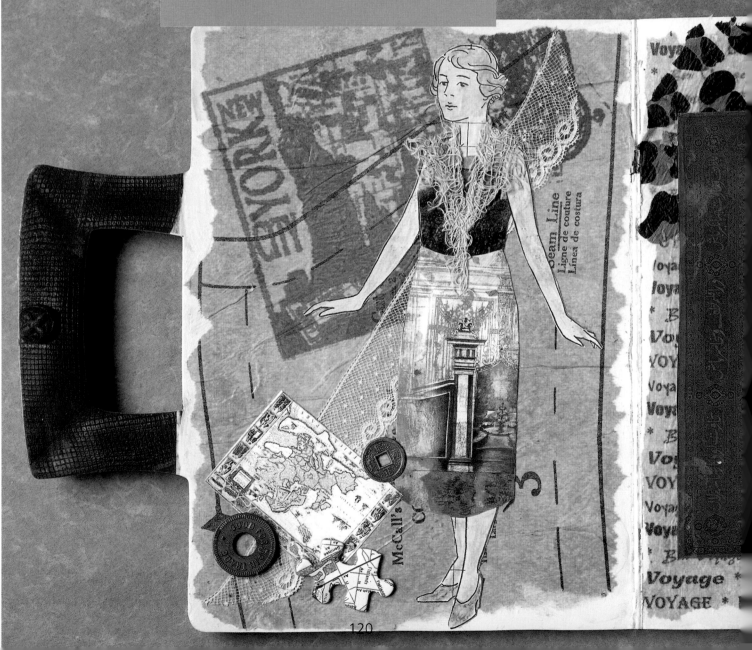

120

Good sources for fashion images are old books and magazines, an out-of-date print catalogue from an art store, and old sewing patterns. I used a tissue paper pattern as a background. Be sure to only use works that are not copyrighted or to alter them so the artwork doesn't look like the original.

I also used rubber stamps and embellishments such as old lace, fasteners, buttons, and buckles I collected over the years. Estate sales are good sources for these items.

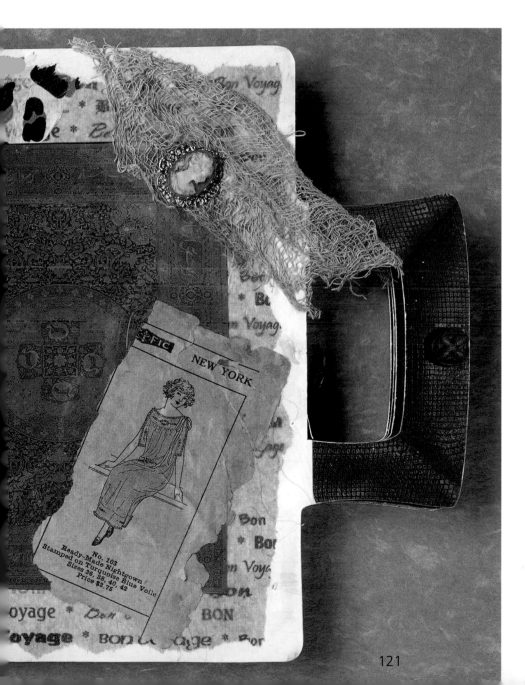

Using Tissue Paper

Tissue paper adds dimension and color without adding bulk. Here are some tips for using different types of tissue. Use white glue or matte medium to adhere tissue to pages.

Solid colored tissue - Adds a soft look over a painted background. For added interest, crumple tissue slightly, then flatten with your hands or a dry iron. The wrinkles add more texture to the finished page.

continued on next page

Using Tissue Paper
continued from page 121

Printed tissue - Use patterned tissue to create patterned backgrounds. Try a leopard or floral print or a piece of an old sewing pattern.

Computer-printed tissue - Create a document with the words or a design you want to use in your collage. Cut a piece of tissue slightly smaller than printer paper. Use tape or a glue stick to adhere one end of tissue to the printer paper and print on your computer.

Stamped tissue - Use rubber stamps to create designs on tissue. The designs can be

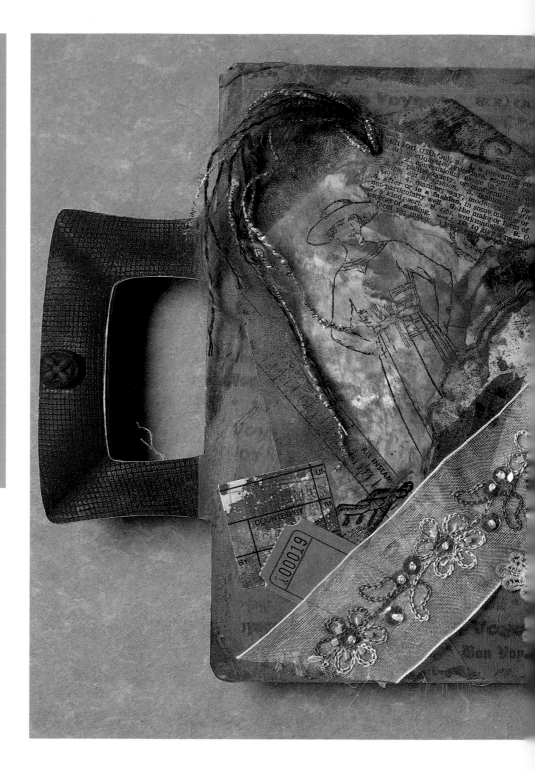

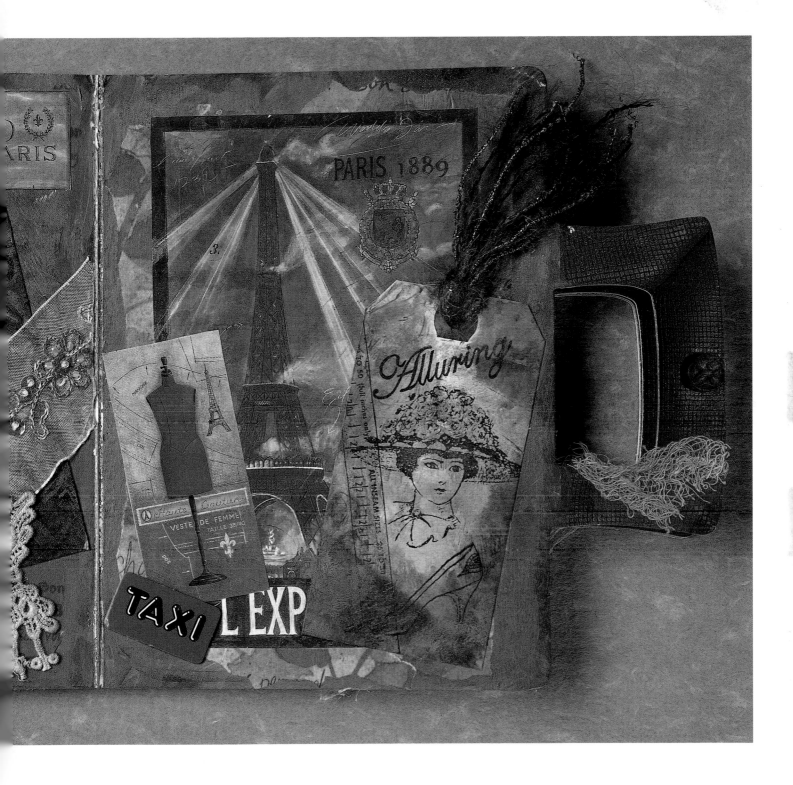

Botticelli-inspired Fabric Book

TO MAKE THIS BOOK COVER, IVORY QUILTING SQUARES ARE STAMPED, STENCILED, AND PAINTED WITH ACRYLIC METALLIC PAINTS. THESE 9" SQUARE PIECES OF QUILTED FABRIC ARE AVAILABLE IN CRAFTS STORES. THEY CAN BE SEWN TOGETHER OR ATTACHED WITH BUTTONS TO MAKE A QUILT OR WALL HANGING.

Quilted fabric squares

For the cover, pictured here, decoupage paper printed with the paintings of Botticelli was color-copied on inkjet fabric, then trimmed

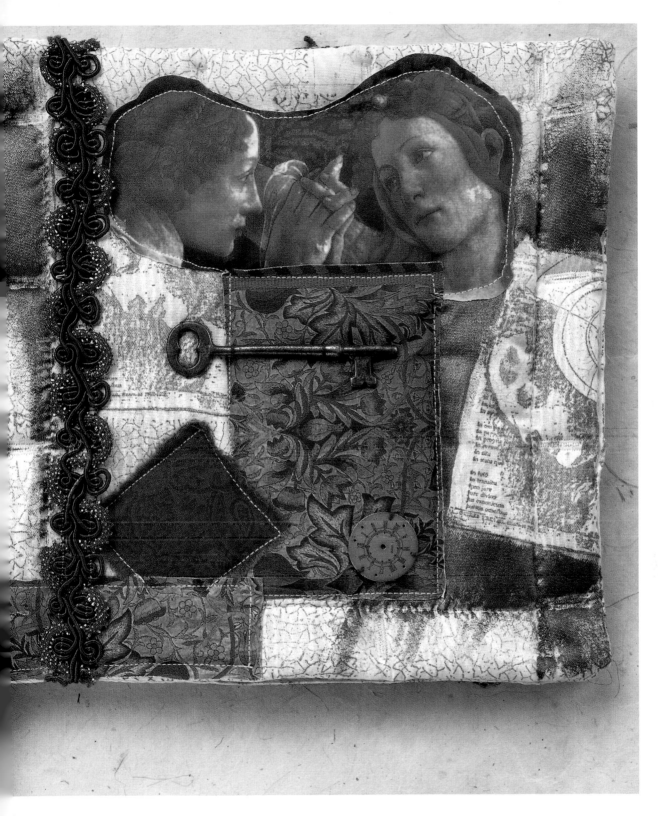

to fit the quilt squares. The inkjet fabric had a fusible adhesive backing, so the pieces could be ironed in place. Machine stitching was added around some inkjet fabric outlines.

Vintage trims, laces, beads, and trinkets were glued with fabric glue or stitched with metallic embroidery floss. The book was bound by tying fibers through buttonholes on the left side.

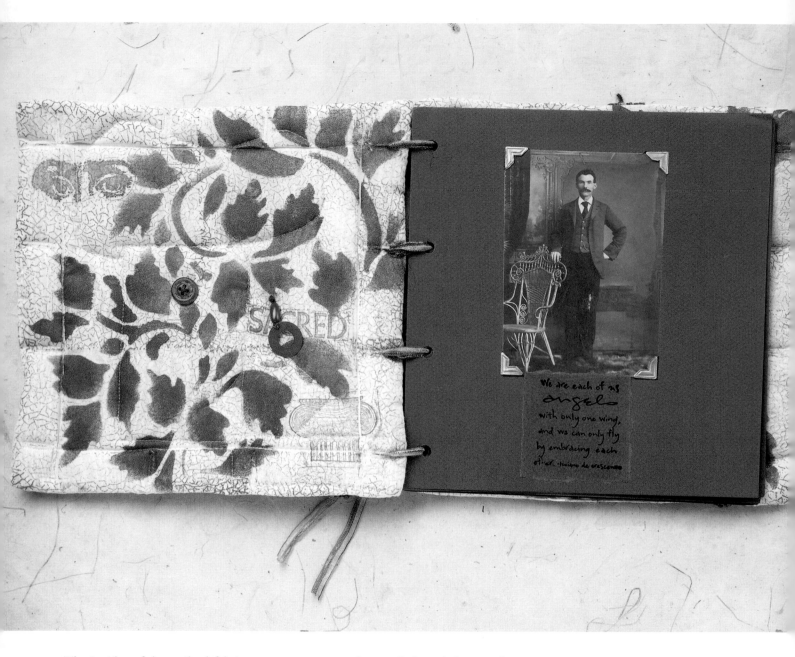

The insides of the quilted fabric cover were stamped, stenciled, and decorated with buttons. Sturdy paper was cut to size to fit inside the covers and punched for the tied-fiber binding.

This page showcases a vintage photo, attached with photo corners, and a saying printed on green handmade paper. The paper colors of the page coordinate with the stamping and stenciling colors used on the inside cover.

Fabric Collage Book Cover

THIS BOOK COVER IS A COLLAGE THAT WAS DIGITALLY PHOTOGRAPHED, THEN INKJET-PRINTED ON CANVAS. THE COLLAGE COMBINES RUBBER-STAMPED IMAGES AND A BINGO CARD. WATERED-DOWN ACRYLIC PAINT ADDS COLOR. A FABRIC STRIP, A CARD OF VINTAGE BUTTONS, AND A TRIO OF METAL WASHERS ADD TEXTURE AND INTEREST.

THE BOOK IS BOUND WITH HOSE CLAMPS FROM THE HARDWARE STORE THAT ARE RUN THROUGH BUTTONHOLES ON THE LEFT SIDE.

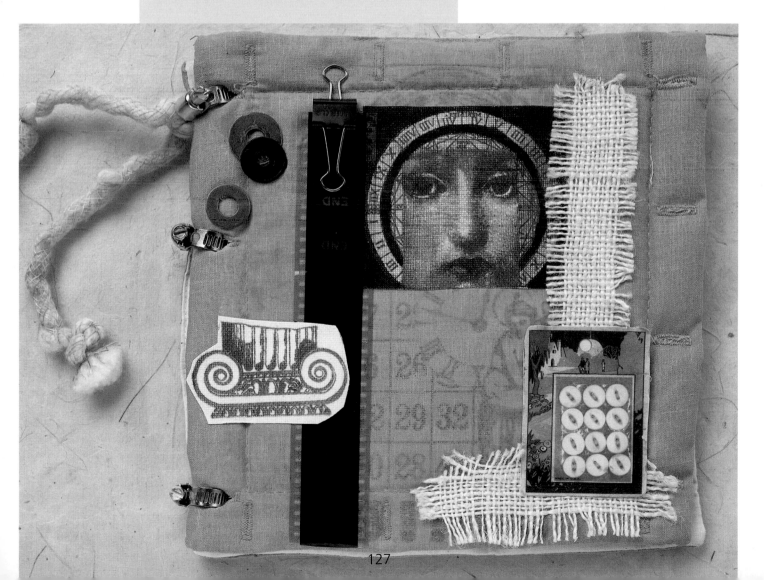

Art of the World Book

THIS BOOK WAS CREATED BY A GROUP OF CRAFTERS WHO CALL THEMSELVES "ART'S ANGELS." THE BOOK WAS SENT TO EACH MEMBER, WHO CONTRIBUTED ONE OR MORE PAGE SPREADS TO THE PROJECT. THE THEME WAS INSPIRED BY THE TITLE OF THE CLOTHBOUND BASE BOOK, *ART OF THE WORLD*.

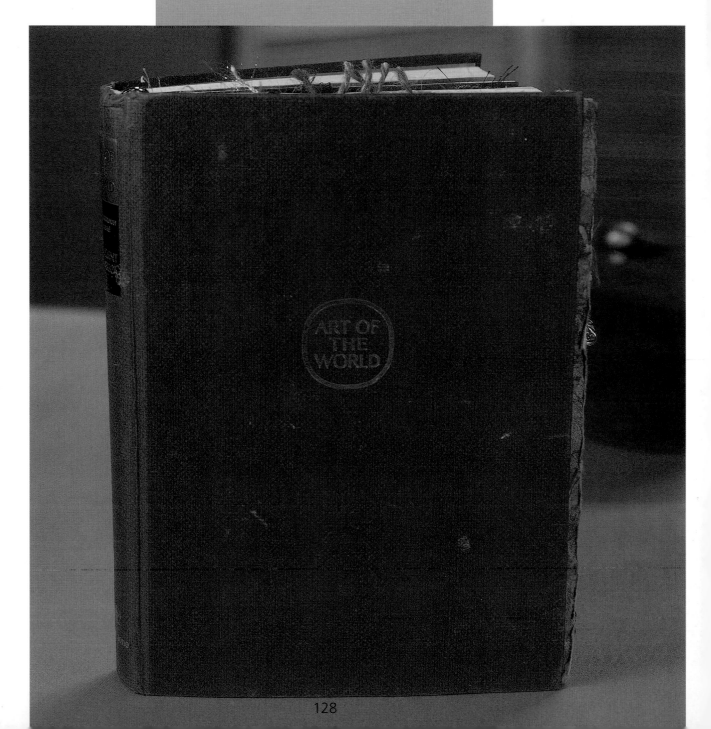

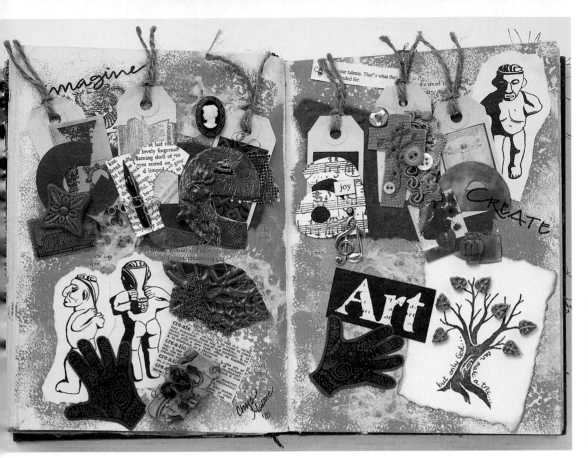

"Create Art"

By Chris Malone

This spread spells out its message in a variety of papers and textures layered over manila tags with hemp twine on a sponged background. Rubber stamping, buttons, charms, paper ephemera, and found objects enchant the eye.

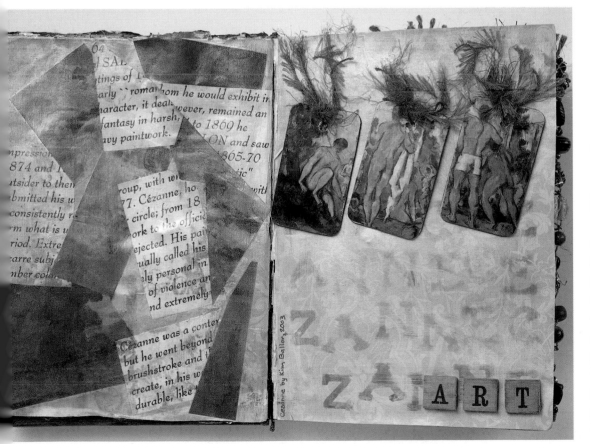

"Cezanne"

By Kim Ballor

This spread celebrates the art of French post-Impressionist painter Paul Cezanne (1839-1906). The collage on the left includes text about the painter; at right, the background is printed with the letters of the artist's name and three fragments from a Cezanne painting are decoupaged on tags.

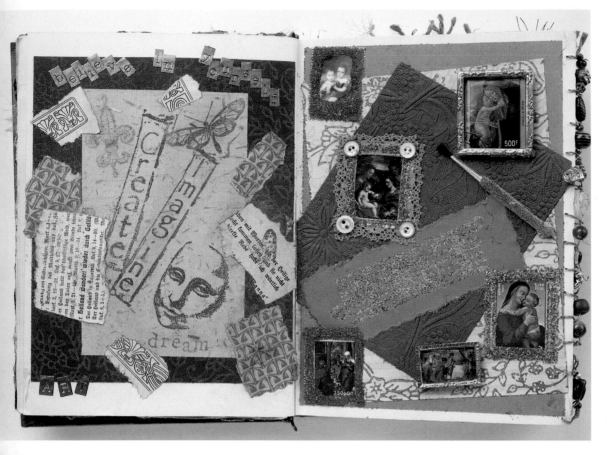

"Believe in Yourself"

By Tracia Williams

Rubber stamps, embossing, fragments of text and paper, and a number of small framed pictures of paintings and photographs of Madonnas and children are brought together on this spread.

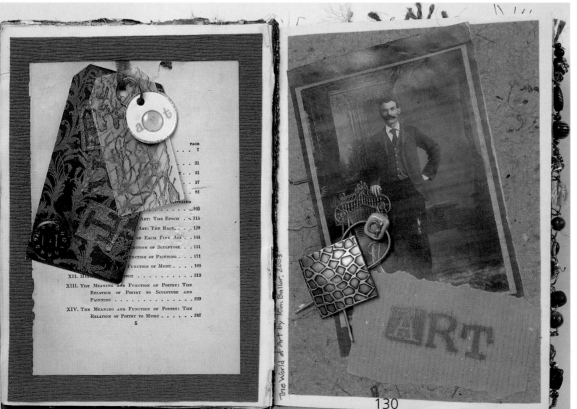

"The World of Art"

By Kim Ballor

A man in a sepia-toned vintage photo (could his name be Art?) from the early 20th century looks confidently at the camera. Opposite, a table of contents page from an art book sits underneath a stack of decorated tags. Metallic objects and metallic ink stamping are gleaming accents.

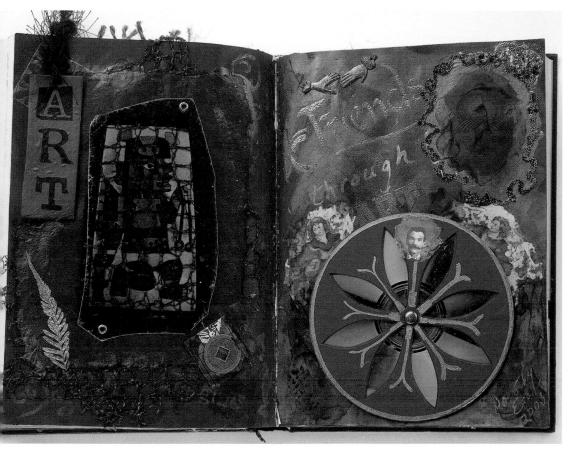

"Friends Through Art"

By Dorothy Egan

Vibrant color and metallic accents are the hallmarks of this spread. Beads, jewels, and charms on the right are balanced by a coin and golden fern on the left. The wheel, attached with a brad, provides movement. It includes the head of the photo of the man from the "World of Art" spread.

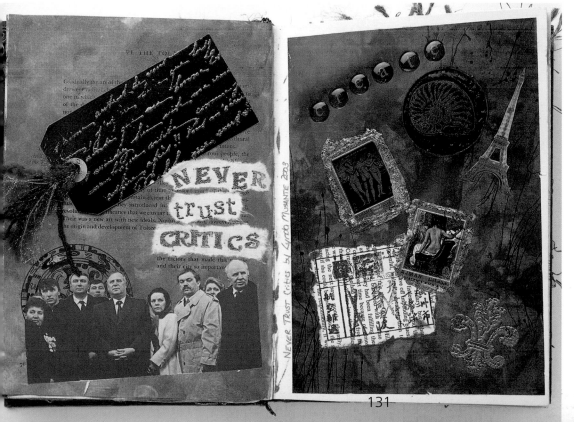

"Never Trust Critics"

By Linda Musante

Script, text, photos, stamping, and art-themed postage stamps are arranged on this spread. The background colors of the two pages complement colors on the opposite page to create unity.

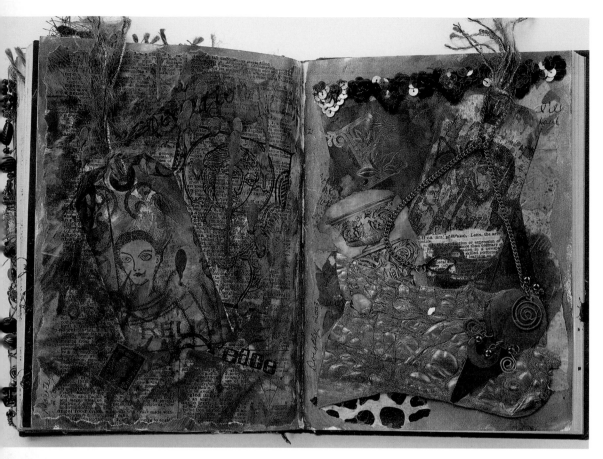

"Inspiration for Art"

By Dorothy Egan

Layers of papers and colors give richness and depth to this spread. Two central images are printed on manila tags that are laced with colorful textured fibers. A necklace of charms on a chain is draped across the page on the right.

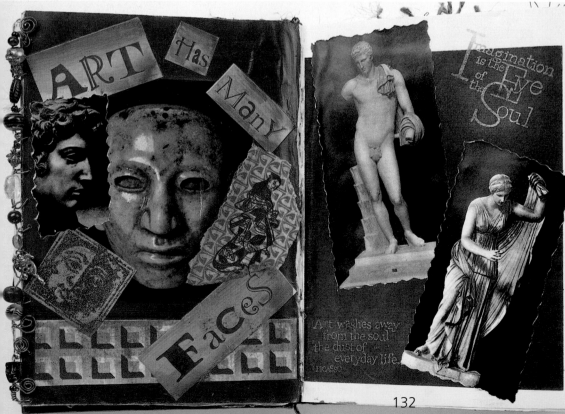

"Many Faces of Art"

By Tracia Williams

These pages combine classical western and eastern figurative images with stamped sayings and ransom-note style letters. Decorative edge scissors were used to trim the classical images. Beads and wire lace the edge of the left page.

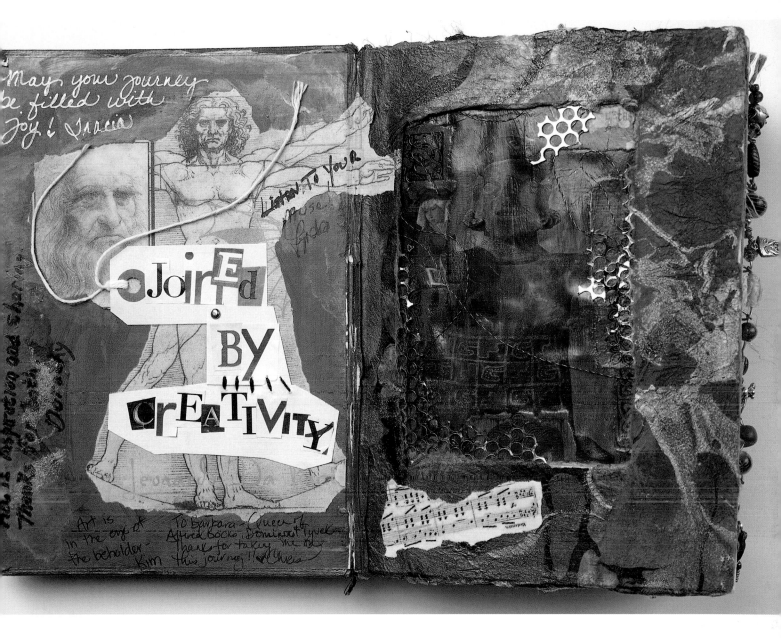

"Joined by Creativity"

Chris, Kim, Tracia, Dorothy, and Lynda wrote messages and signed the page at left around and over copies of drawings by Leonardo da Vinci that overlap the multi-layer collage at right.

The Family Book

A CHILDREN'S BOOK ABOUT FAMILY WAS THE BASIS OF THIS ALTERED BOOK. THE ARTIST WANTED TO SHOW THINGS THAT "TOGETHER" MAKE UP HER LIFE. COLLAGES MADE FOR THE PAGES INCLUDE NEEDLEWORK ABOUT HER FAMILY, ITEMS ABOUT HER IRISH HERITAGE, AND HER FAVORITE PASTIMES OF SEWING AND QUILTING.

By Christine Malone

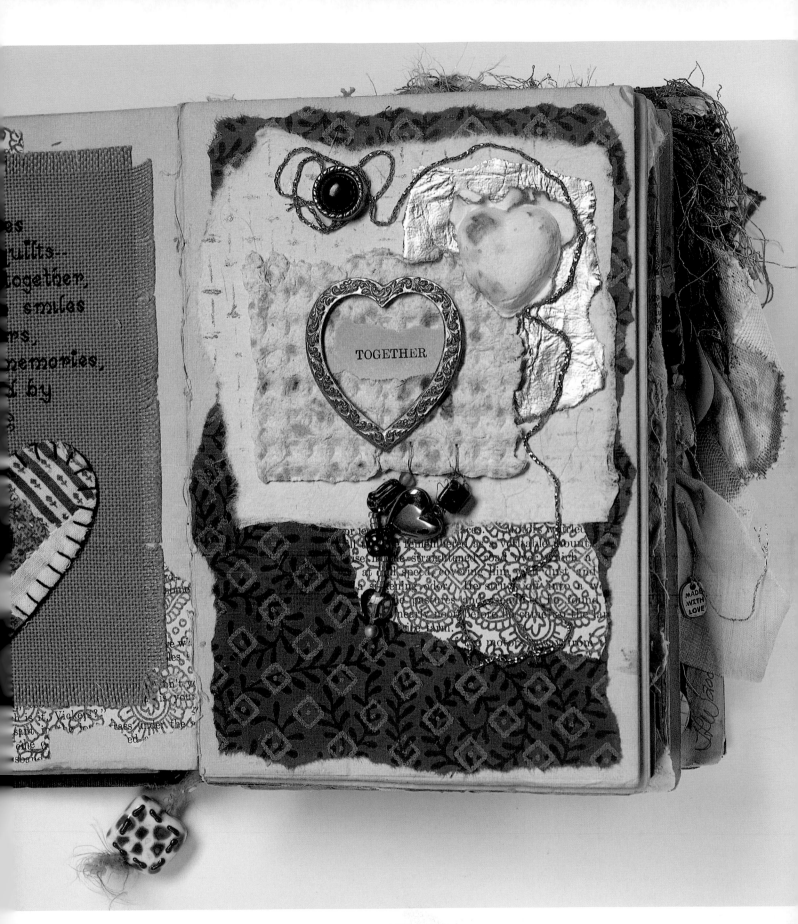

continued from page 134

The heart-felt altered book that Chris and her friends created was inspired by an old book that she found with the title "Together." (See page 134 that shows the cover of the book.) After she found this book she decided she wanted to create pages for herself, and then send the book around to her friends in the "Art's Angels" group and allow them to create pages along this same theme. She asked them to do pages that relate to the parts of *her* life that work "together" to make it uniquely hers. She had included a list of things that are important to her, such as family, friendship, her love of sewing and quilting, her Irish heritage, and more. When the book returned to her with completed pages, it was like looking at your life through your friend's eyes. It is a book she will always treasure. ❏

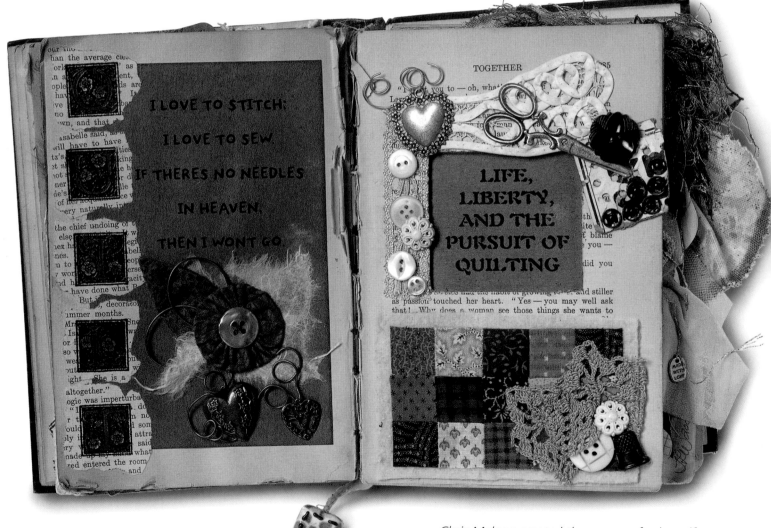

Chris Malone created these pages for herself.

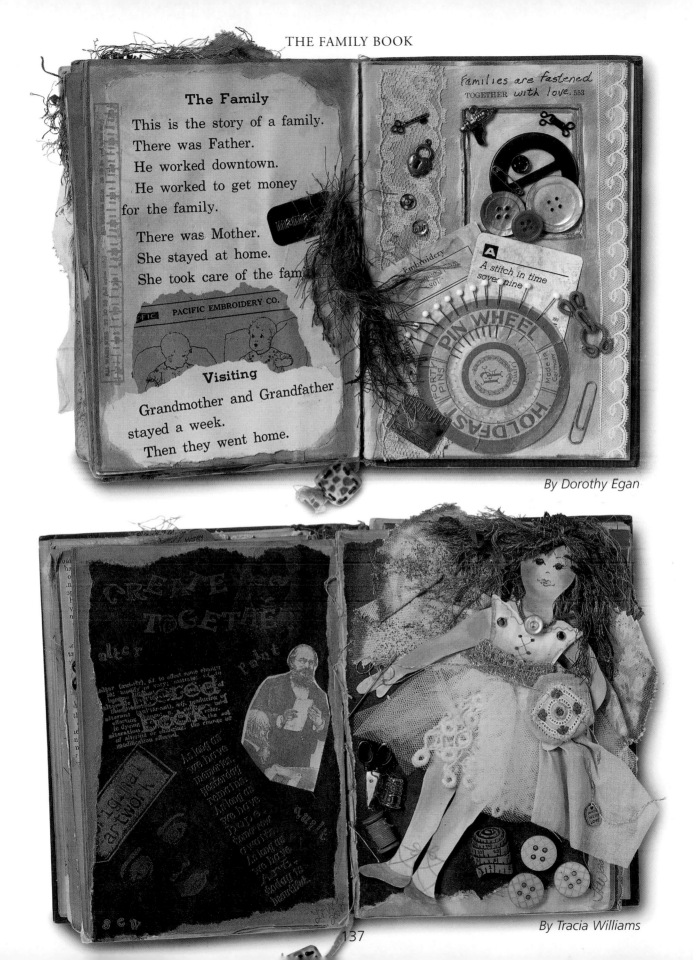

By Dorothy Egan

By Tracia Williams

Tips for No Cooking Book

A VINTAGE COOKBOOK WAS THE STARTING PLACE FOR A HUMOROUS
ALTERED BOOK ABOUT THE JOYS OF **NOT** COOKING. A VARIETY OF
COLLAGE TECHNIQUES WERE USED TO CREATE THE FUN-FILLED PAGES.
FOR SOMEONE WHO DOESN'T COOK, THIS COULD BE THE ONLY
COOKBOOK ON THE SHELF.

By Lynda Musante

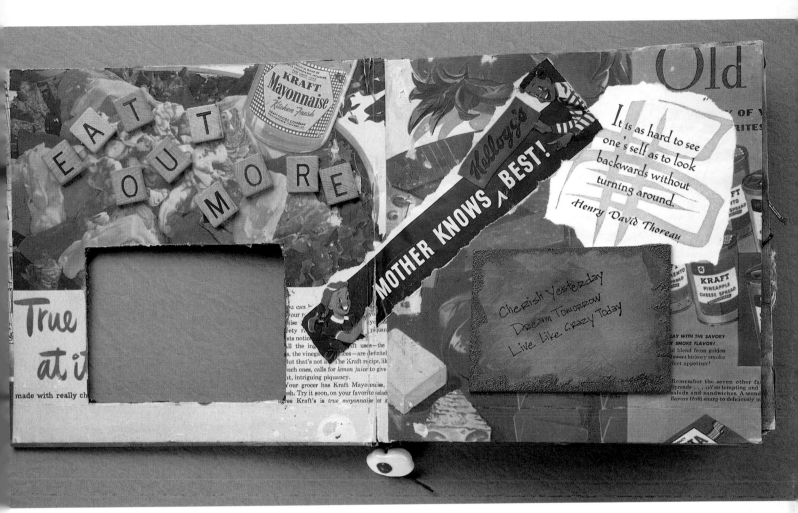

Pictured above: This is the inside front cover (with the window) and the page with the leather piece that shows through the window. Scrabble game pieces spell out the message "Eat Out More."

The Cover

Much of the vintage cookbook's cover was retained. A window was cut in the cover and outlined with gold ink. A piece of tanned leather, cut smaller than the window, was attached to the page behind the window. The artist's sentiments about why she doesn't cook were written on the leather. The cover collage materials include sheet music and handmade paper. Scrabble game pieces spell out "No Cooking."

The Pages

The following pages show some of the collage page spreads created for the "No Cooking" book.

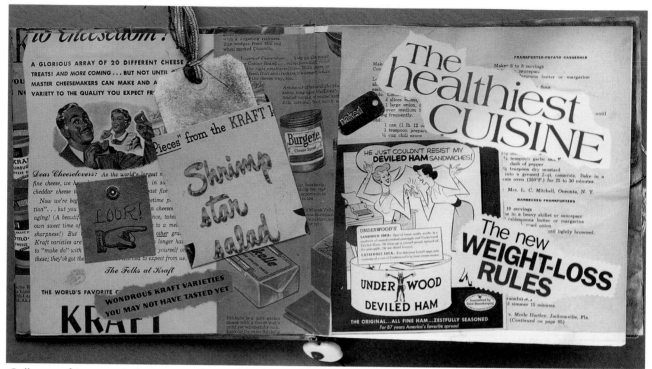

Collages of type and pictures cut from old magazines adorn this spread. A rubber-stamped hand points to an envelope that holds a decorated tag.

Washes of acrylic metallic paint obscure the recipe on the left page; the one on the right is decorated with glue and glitter.

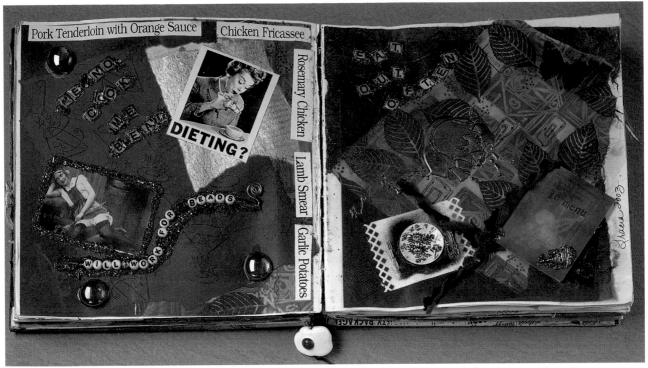

The two pages in this spread are unified by common colors. The spread on the left celebrates beading over cooking and includes a picture of an unhappy dieter; the one on the right invokes a restaurant table and includes the words "Eat Out Often."

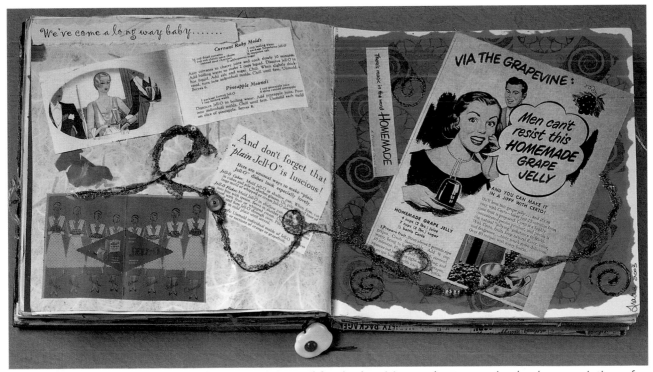

This spread provides a trip down the memory lane of food advertising and a tongue-in-cheek appreciation of home cooking.

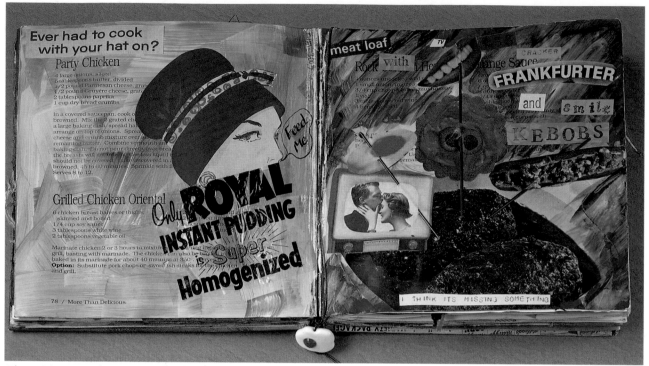

The recipes on the pages are obscured by color and layered over with images and type.

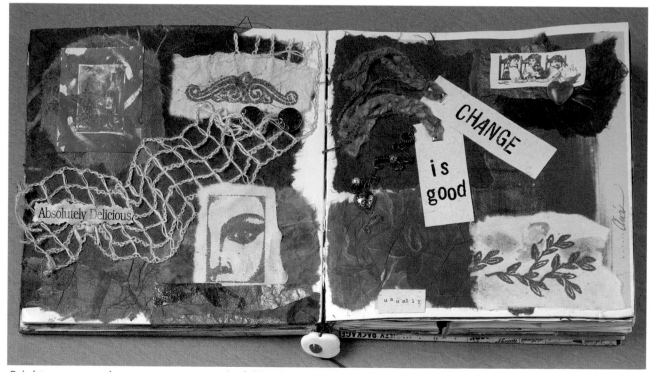

Bright papers and textures create a colorful background for rubber stamped images and three-dimensional objects.

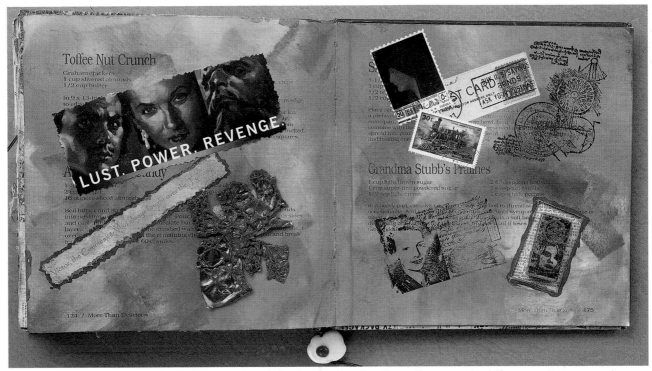

A toffee recipe provided the background and the inspiration for the collage on the left page. Stamps and rubber stamped images are seen at right. The fried egg bookmark is a whimsical touch.

Metric Conversion Chart

Inches to Millimeters and Centimeters

Inches	MM	CM	Inches	MM	CM
1/8	3	.3	2	51	5.1
1/4	6	.6	3	76	7.6
3/8	10	1.0	4	102	10.2
1/2	13	1.3	5	127	12.7
5/8	16	1.6	6	152	15.2
3/4	19	1.9	7	178	17.8
7/8	22	2.2	8	203	20.3
1	25	2.5	9	229	22.9
1-1/4	32	3.2	10	254	25.4
1-1/2	38	3.8	11	279	27.9
1-3/4	44	4.4	12	305	30.5

Yards to Meters

Yards	Meters	Yards	Meters
1/8	.11	3	2.74
1/4	.23	4	3.66
3/8	.34	5	4.57
1/2	.46	6	5.49
5/8	.57	7	6.40
3/4	.69	8	7.32
7/8	.80	9	8.23
1	.91	10	9.14
2	1.83		

Index